NOV 2 3 2008	
SEP 01 2009	
SEP 2 9 2009	3
GAYLORD	PRINTED IN U.S.A.

Eairie-ality

398.45 FAI

Glenview Public Library 1930 Glenview Road Glenview, Illinois

Spring. . . . the word itself sounds zesty. Like something exciting's going to happen. It's my favorite time of year and J'll tell you why-it's The Season. Even before last frost, invitations fly in from everywhere for cotillions and concerts, picnics and parades. Midnight games and twilight gambols. Svening flights and daylight rambles. It begins when the bluebells bloom, and by the end, when sun spills into midsummer, the fields are loaded with daisies and roses. The middle is filled with parties and play.

You'll see . .

Spring. . . the word itself sounds zesty. Like something exciting's going to happen. It's my favorite time of year and J'll tell you why-it's The Season. Even before last frost, invitations fly in from everywhere for cotillions and concerts, picnics and parades. Midnight games and twilight gambols. Evening flights and daylight rambles. It begins when the bluebells bloom, and by the end; when sun spills into midsummer, the fields are loaded with daisies and roses. The middle is filled with parties and play.

Coull see . . .

In the fairie world there is one top designer of couture and accessories. This catalogue brings together his brand-new collection for the very first time . . .

THE SEASON approaches, and it gives us the greatest pleasure to present the new spring line from the renowned House of Ellwand. Addressing all your requirements, from impeccably tailored flywear for urban and field outings to elegant ball gowns and eveningwear—not to mention the freshest visions in unmentionables—the celebrated *couturier* conjures fabrics from fantasy and dresses from dreams.

Ellwand keeps his *atelier* in the ancient bluebell groves of West Sussex. Outside, a tiny unmarked door offers no sign to passersby, for the creator needs his privacy. Inside, masses of wildflowers, dried grasses, feathers and seedpods, pine cones and polished pretties surround the designer as he works late into the night, turning his passionate visions into one-of-a-kind realities.

Peek into the pamphlet here for a preview of Ellwand's dazzling creations. This year, for the unwinged, we are pleased to include a line of flight hats. Made to the most stringent design standards, these trendy toppers also provide maximum lift. Indeed, in recent trials, our hats have proven unmatched as flying aids. If you're winged, you won't need our hats for flight, but you'll certainly want them for fashion. Just as many heads will turn! A final word about your selections. In-country orders will not, of course, require size specifications because of the shape- and size-changing abilities of our clientele. However, international orders must be handled on an individual basis and require an additional two weeks' shipping time.

Those of you who have dealt with us in the past know of our commitment to flexibility and our imaginative openness to the payment process. To those of you joining us for the first time, we say *bienvenue*. We look forward to assisting you.

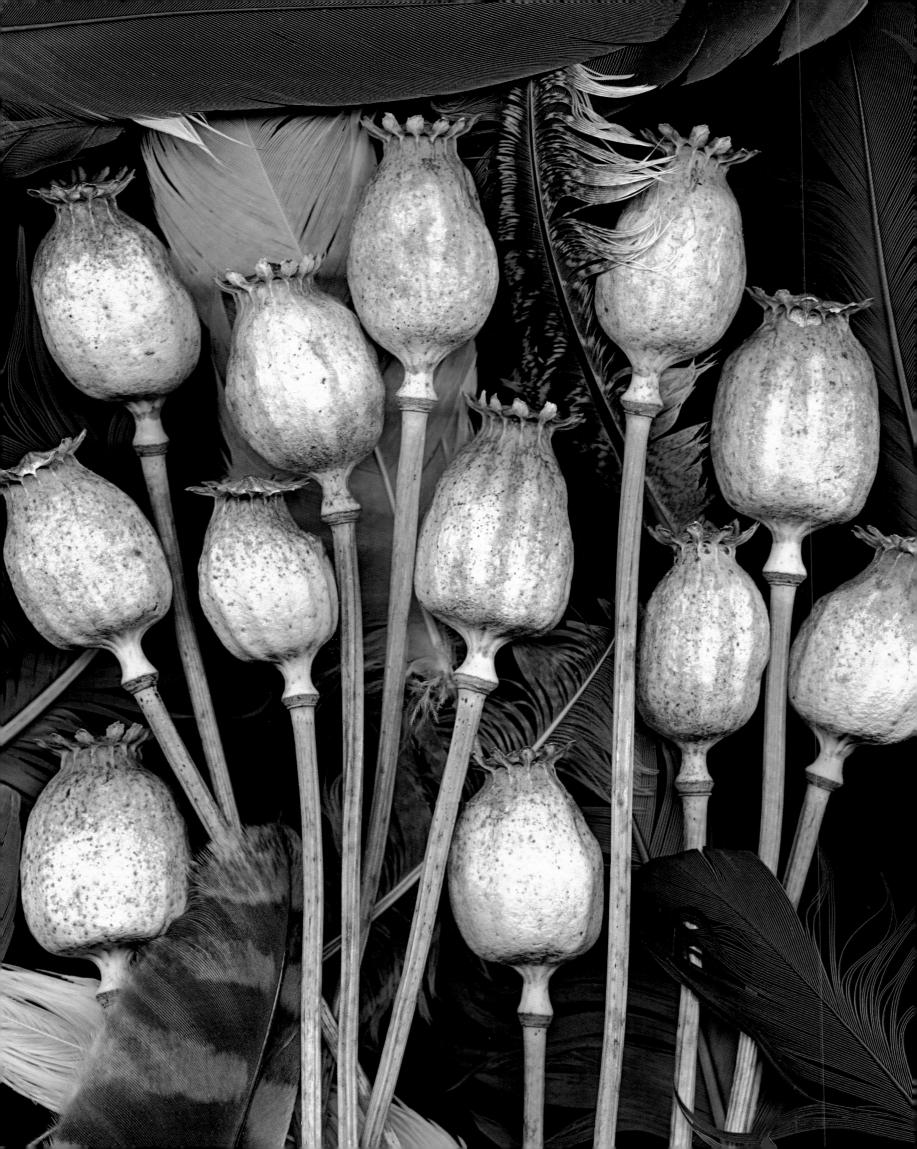

H.R.F.H. The Queen requests the pleasure of your company at the Cotillion of the Pheasant on the First Full Moon After the Bluebells Bloom at Sunset in the Oak Grove _____ The Presentation to The Queen Will be followed by the Flying Figures, Dinner, and Dancing R.S.V.P. Royal Acorn Post

We're leaving now for the Mut Tree Thicket, where the cotillion gowns are awaiting their owners. Sach dancer will need a helper to fluff her feathers and adjust the fastenings - my sister Lavinia chose me! At sunset, Lavinia will open the ball by presenting the bluebell nosegay to the Queen, and next, all the girls will perform their flying figures. They must execute them perfectly - a single missed turn or delayed hover could mean catastrophe. Later, after the banquet, we'll all get to dance and fly.

Jt's going to be a magical night!

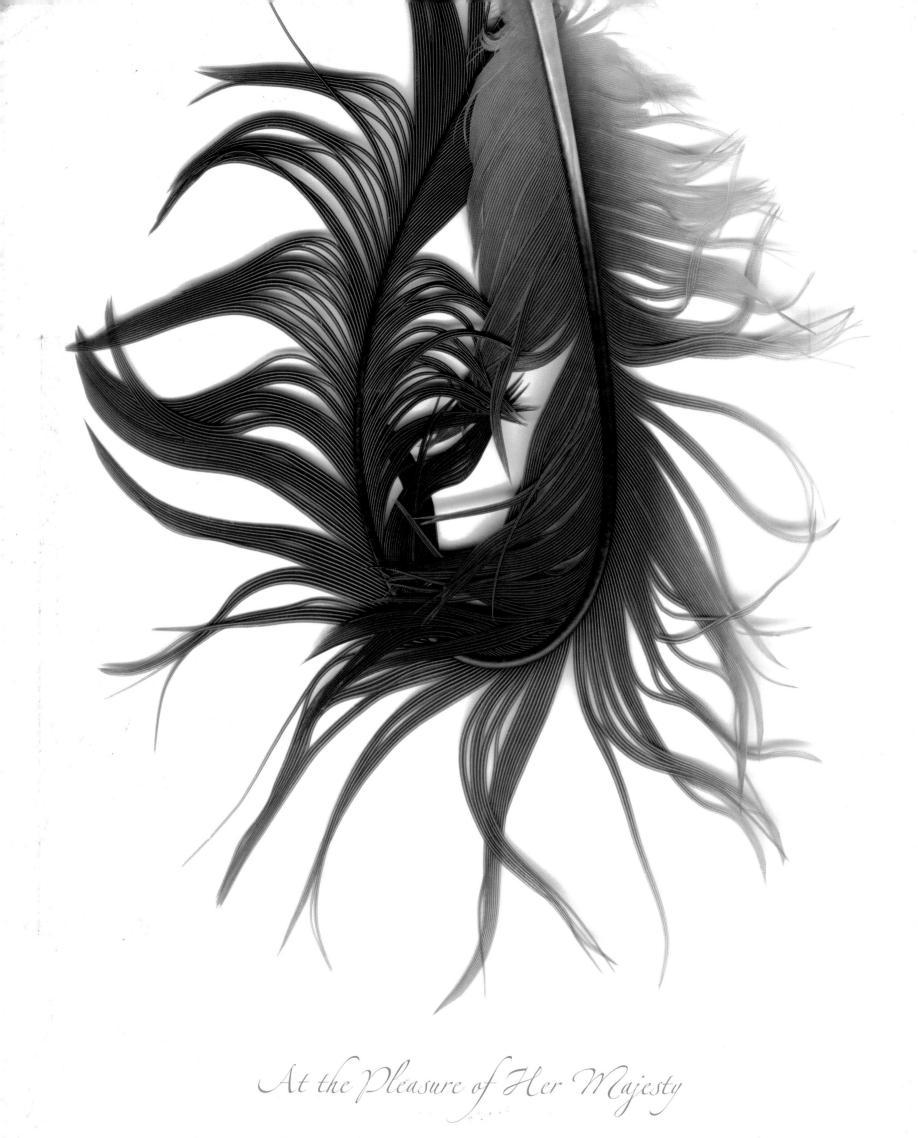

Everyone gasped as Violette floated by in her parrot feather gown. She had a way of dancing and flying that caused all the other fairies to stop and stare, though she never seemed to notice.

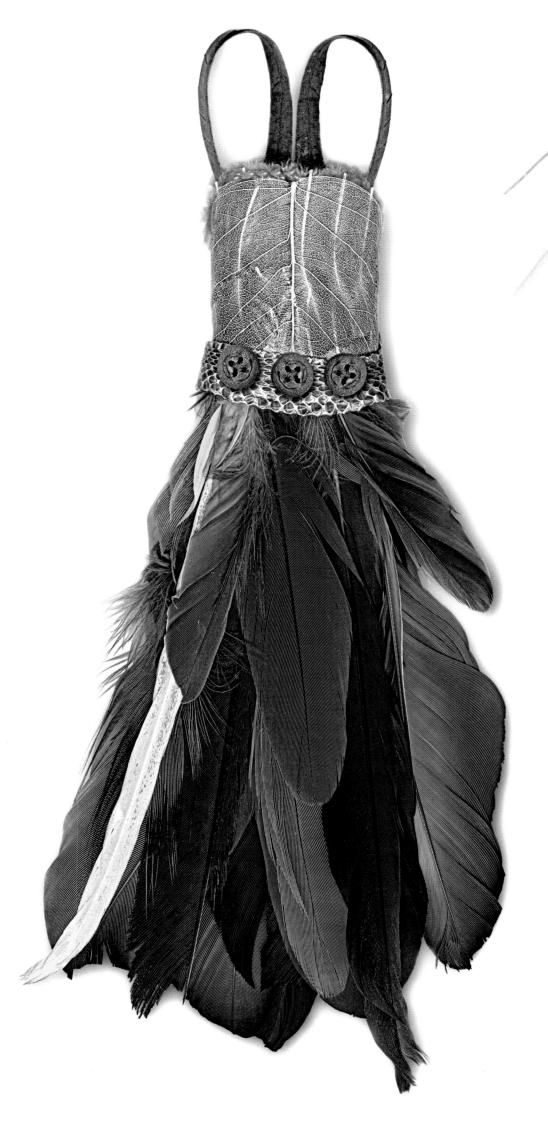

Violette's Gown

Exotic parrot feathers; snakeskin belt with red gum seeds. Skeleton leaf cobwebbing and simple alder leaf straps on the bodice. No pheasant for this rebel! There sleeps Titania

some time of the night, Lull'd in these flowers with dances and delight; And there the snake throws her enamell'd skin,

Weed wide enough to wrap a fairy in.

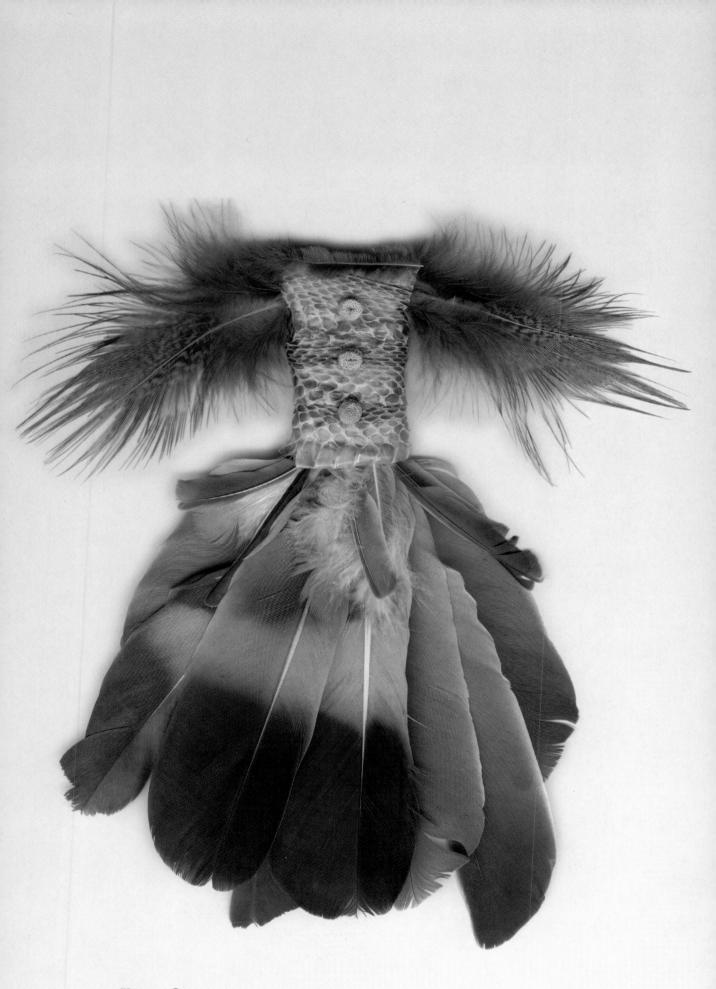

Titania Gown

The Bard himself could not have thought up the unlikely, skin-tingling combination of pigeon (the skirt) and pheasant (the sleeves) with a constricted snakeskin bodice.

Just shed your snakeskin bodice to reveal this second skin.

> Underwear? Of course. Swimwear? Why not?

Postmidnight Dip

These splendidly mentionable unmentionables are trimmed in honesty seeds.

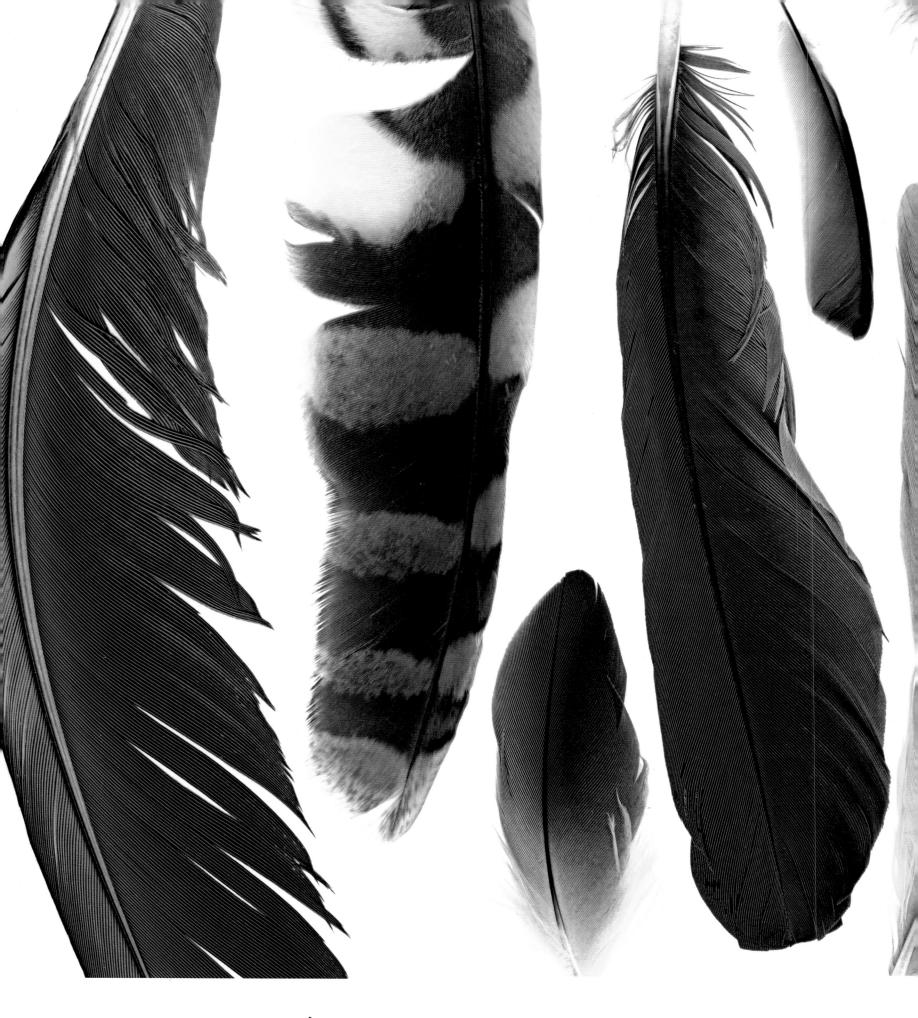

(Who says feathers are just for the birds?

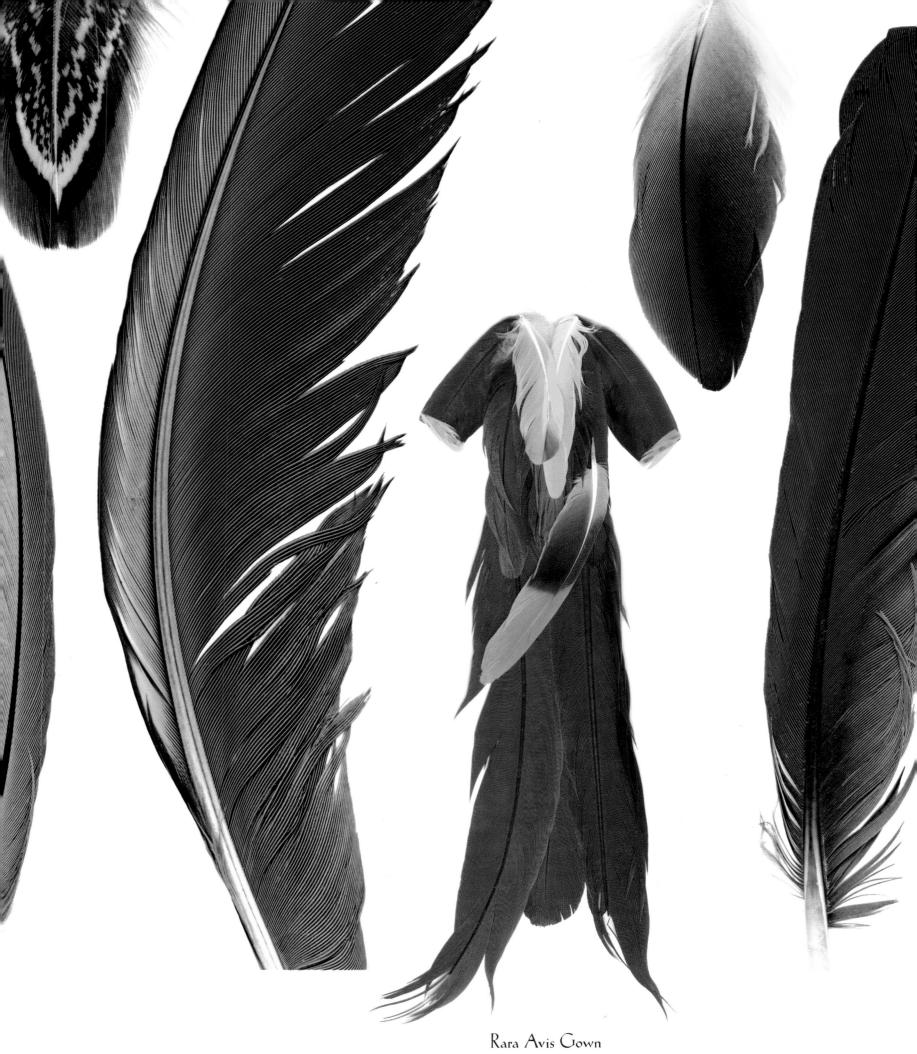

lridescent hues of parrot blue and green, intensified by a flick of yellow at the neck and cuff.

If your own presentation to the Queen is just a pleasant memory, but now you're pleasurebent, we have the perfect gown. You were the first in your Cotillion class yesterday, and you're the *dernier cri* today.

1

ACC

Coup de Grace

Shaped parrot feather skirt with strapless bodice of sweet chestnut and a zigzag of monkey puzzle spikes at the waist. A jewel in the crown for the sophisticate who's young at heart.

The Streamlined Mule

Just the heel to slip on when you plan to dance and dazzle. Upper of rose petals with cow parsley seed trim; birch bark sole.

The Paradox Hat

0

1

What emerges from these ominous roots and bulb when they're at home? A cheery crocus! Here the roots have a firm grip on lime-green parrot feathers. To be worn by those who cherish mystery.

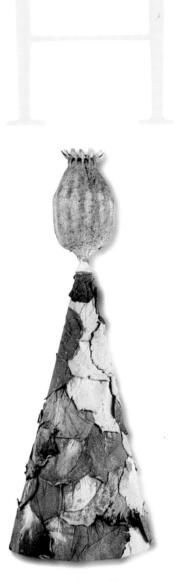

The Rose Poppy Topper

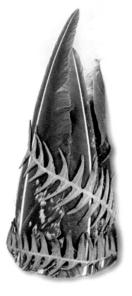

The Fern Frond Miter

The Pumpkin Zeppelin

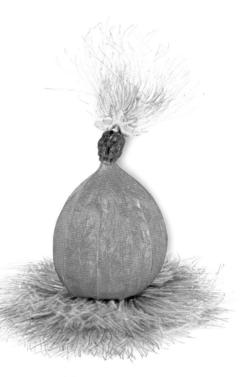

The Plumed Blimp

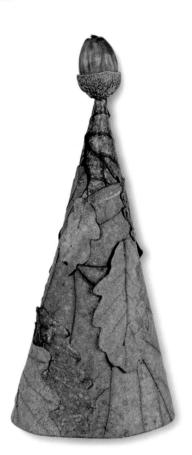

The Squirrel's Delight

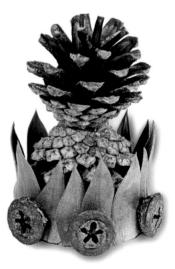

The Baby Beanie

floating and flitting on airy heights takeoff.

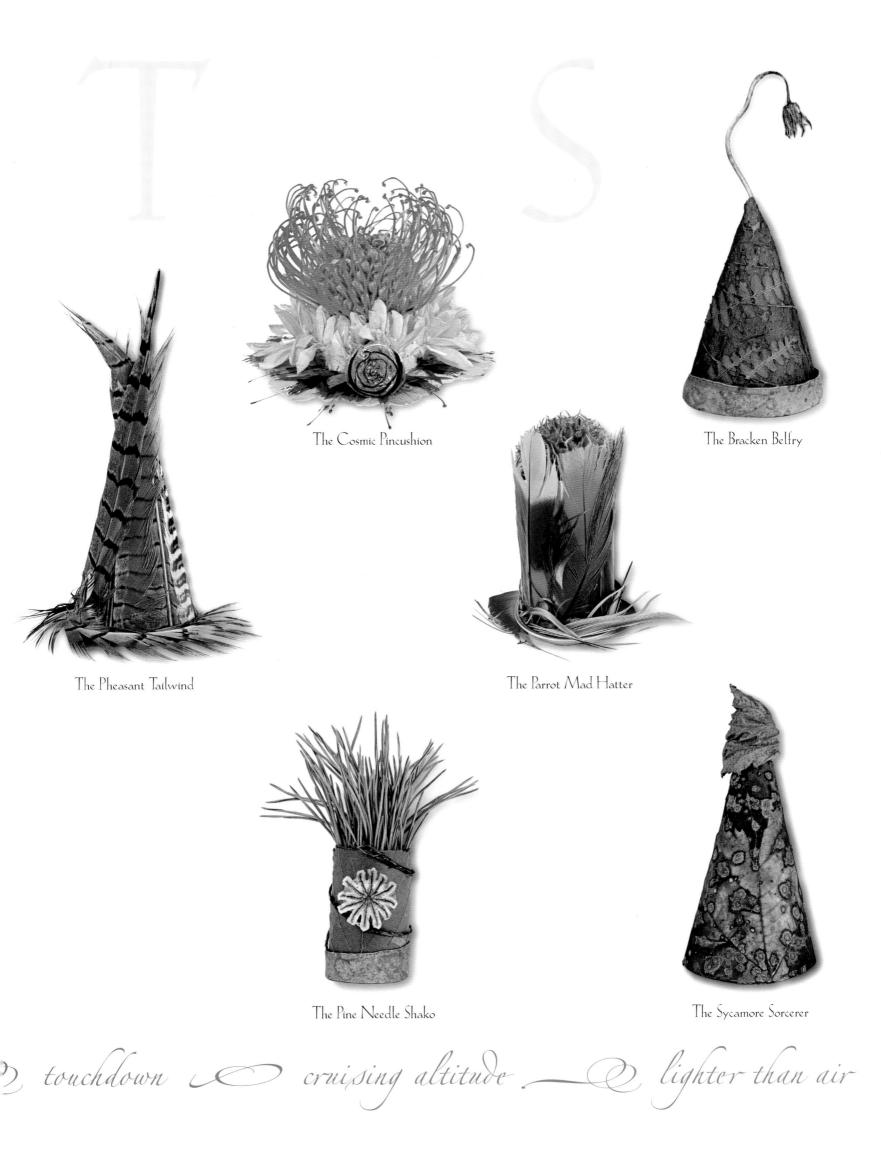

The Language of Love

F

Gather the flowers whose sentiments express your message, placing the most important flower in the center. Make a collar of lady's mantle or ivy to surround the flowers. Firmly bind all the stems together with ribbon grass or feather thread, finishing in a bow.

Secretly place your tussie mussie on the threshold of your sweetheart's, beau's, or best friend's house then fly away so you won't be discovered.

J've been waiting all year for tomorrow -Jt's May Day! Before cockerow, J'll be picking fresh buttercups and cowslips, dianthus, violets, and red currant to make little tussie mussies. J'll tuck them in the roots by my best friends' houses. J'll weave the rest of the flowers into a garland and wear it when we dance around the white hawthorn tree.

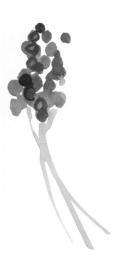

Bougainvillaea: Slegance Bridal Wreath: Happiness Buttercups: Childhood memories Calla Lily: Female beauty Columbine: Determined to succeed Cosmos: May I have the next dance? Cowslips: Divine beauty Daisy: JANOCEACE Dianthus: Make haste Dock: Patience Fuchsia: Mumble love Gerbera: Beauty Hyacinth: Sorrow Jvy: Marriage Lady's Mantle: Comfort, protection Lilac: First love Lily: Purity Mint: Virtue Parsy: You occupy my thoughts Pinks: Fascination Queen Anne's Lace: Fantasy Red Currant: You please me Red Rose: Love Violet: Fidelity

The revelry celebrating

High Spring lasts all day,

but at dusk the band packs

up and goes home -

which is perfectly fine

with this pair, who

keep dancing to the

only music they need:

the wild beating of

their own hearts.

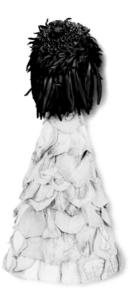

Rose Pierrot Rose petals with pompom of gerbera daisy.

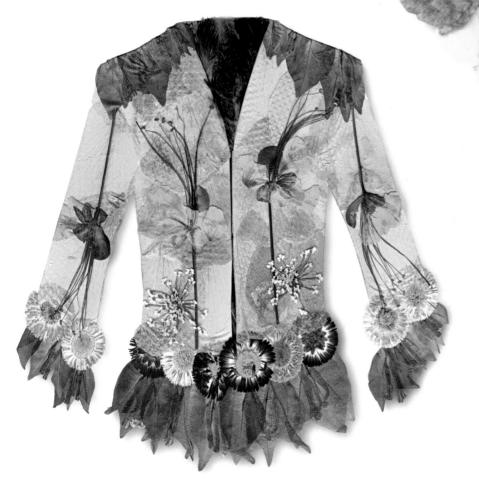

Rose Jacket for Him Bougainvillaea with Mexican bird of paradise, daisies, a dusting of Queen Anne's lace, and most important, rose petal flourishes at cuff and hip. Rose Dance Dress for Her Luscious sculpted layers of lily and rose petals. For one with a heart full of passion.

Made for Sach Other

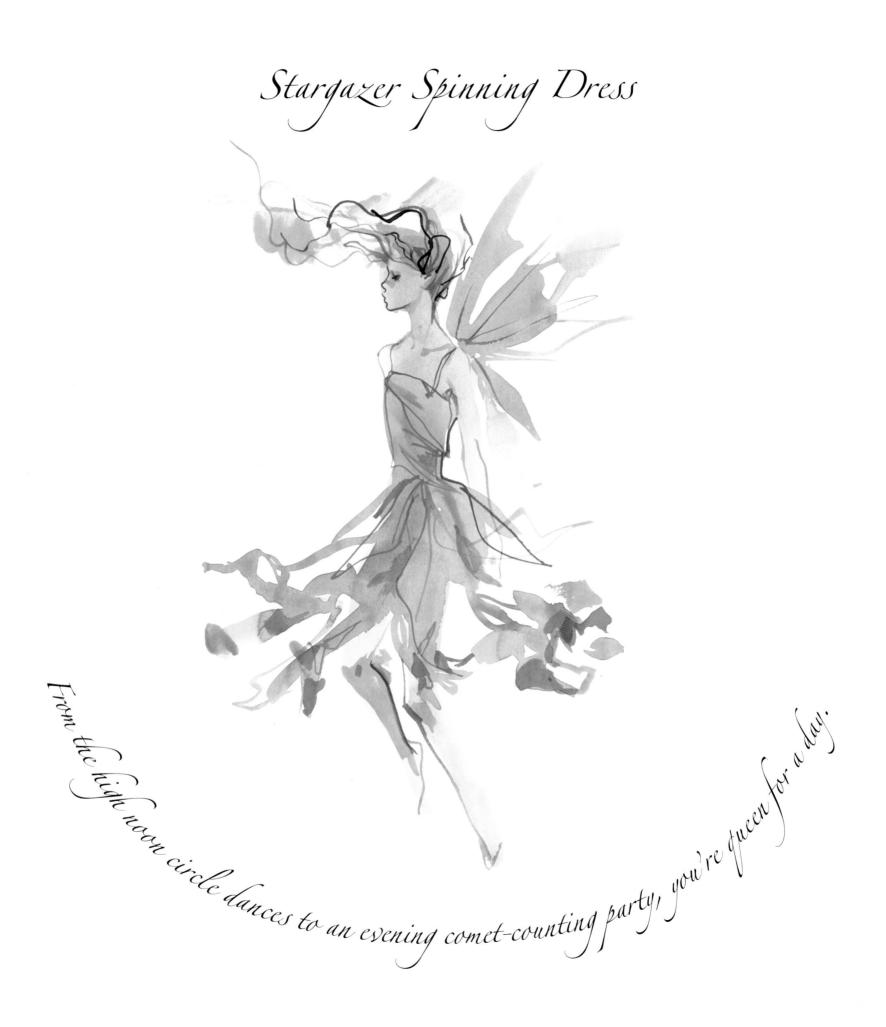

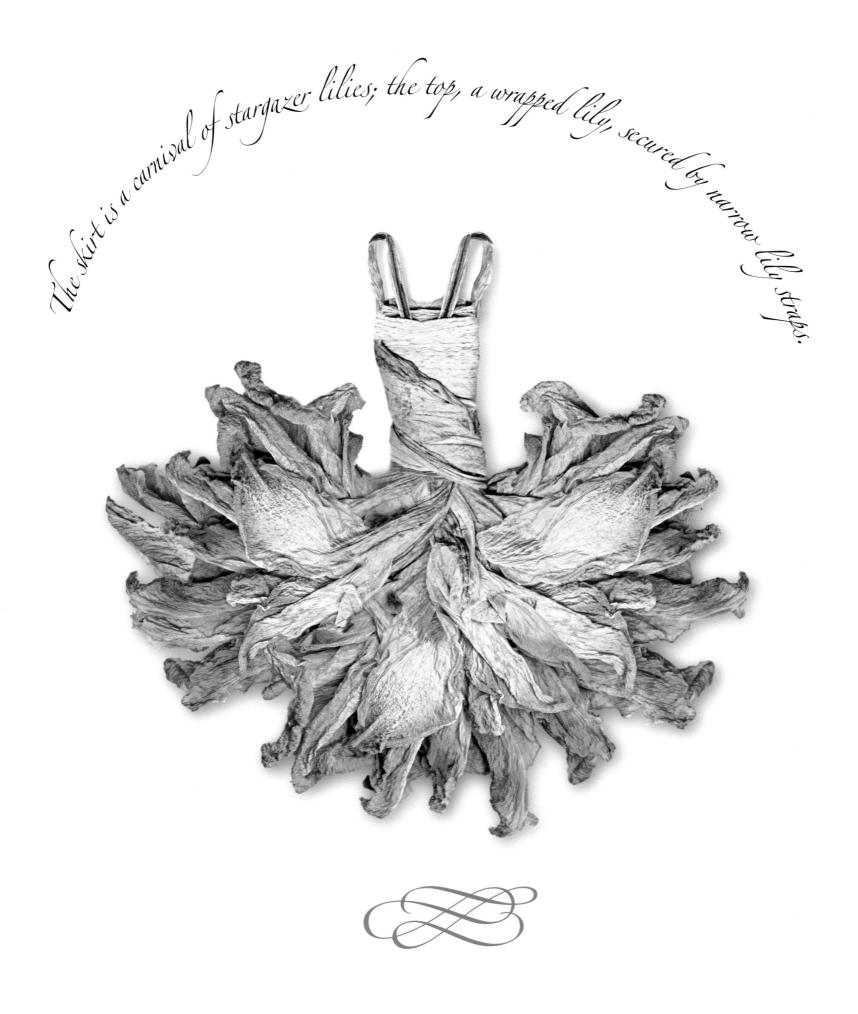

When the Rade Passes By

When the royal family passes by in the Fairie Rade, everyone holds still. In the hush, they can hear the wind blowing through the tiny whistles nestled in the horses' manes; the ringle-jingle of the belled bridles; the musical clip-clop of the Lilliputian hooves. The riders' mounts are the colors of a late spring garden: hyacinth, fuchsia, rose, lilac. We like to ensure that our Rade regalia is equally vivid.

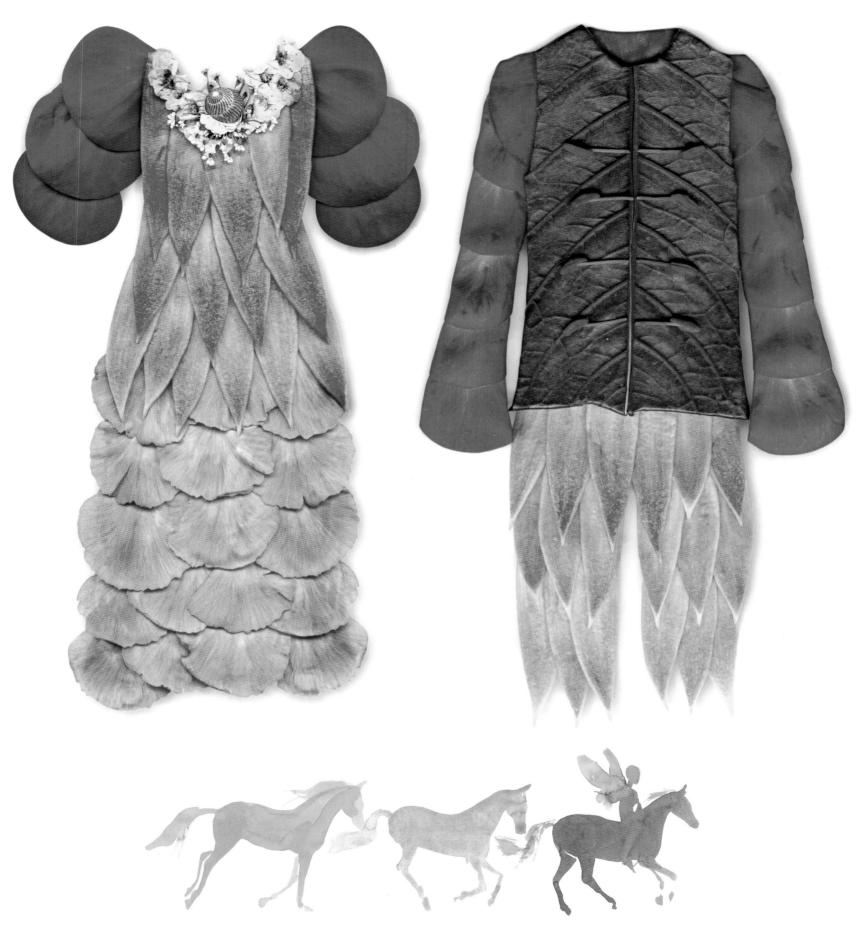

Harlequin Dress

Layers of pink dianthus ruffle the frothy skirt of this dress. Bodice and sleeves of piercing fuchsia with a necklace graced by bridal wreath, pinned with a seashell.

The Jockey Jacket and Knee Britches

Brilliant fuchsia bell-shaped sleeves and trousers. Military rows of stamen fastenings march down the fuchsia leaf vest.

He says____ May I request the honour of the next two dances? (I don't stand a chance. She's so sophisticated and stunning. Will she find me too fiddle-footed and tatty?)

She says -I am pleased to accept.

(He's so suave and dashing.

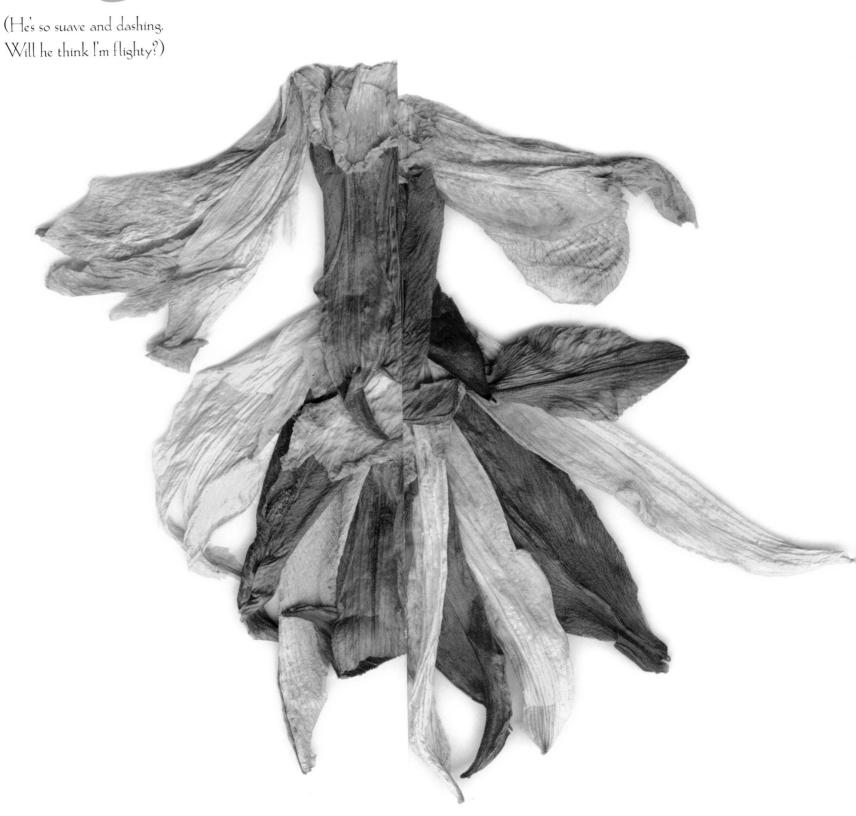

Vintage roses appliquéd over TMCC white lily petals. The lasish pu lilac hem will whisper when you walk in this enchanted and enchanting Rosebud Gown.

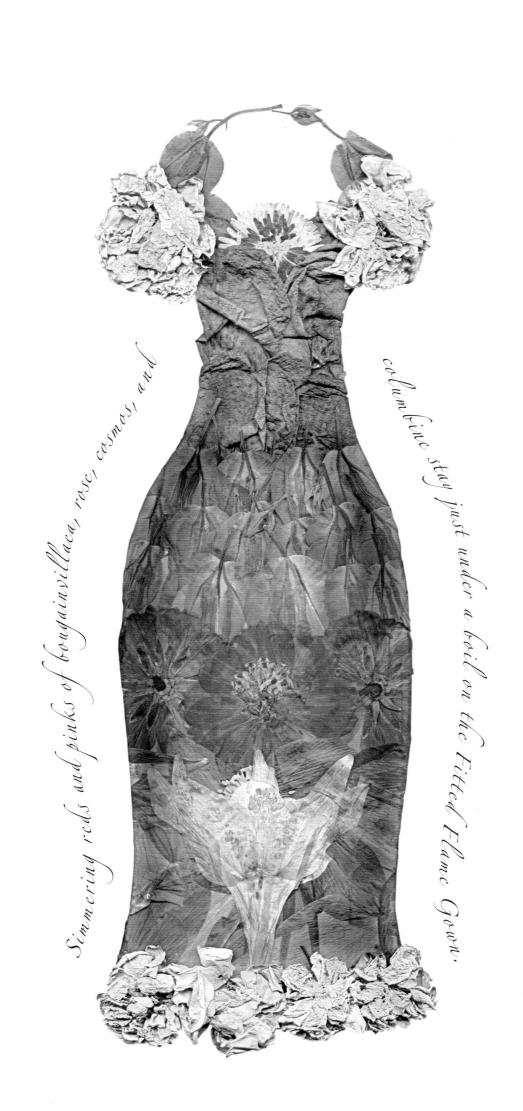

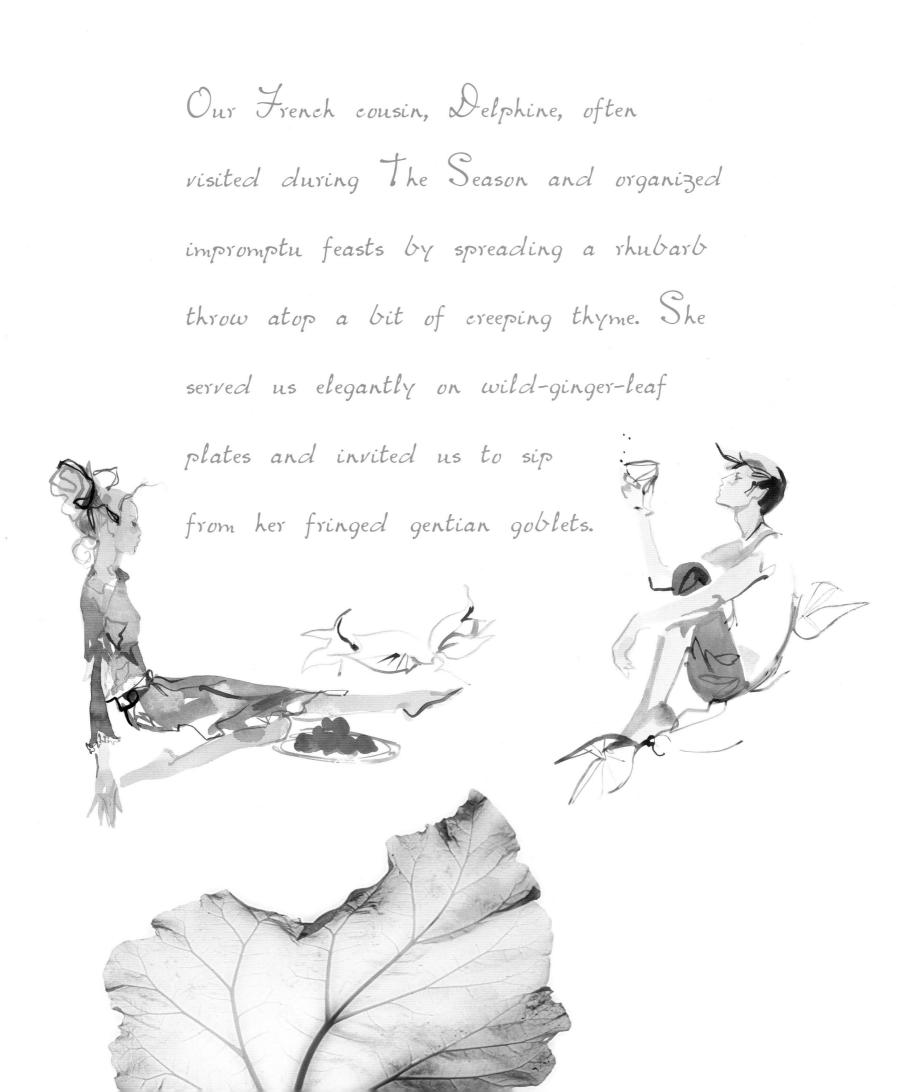

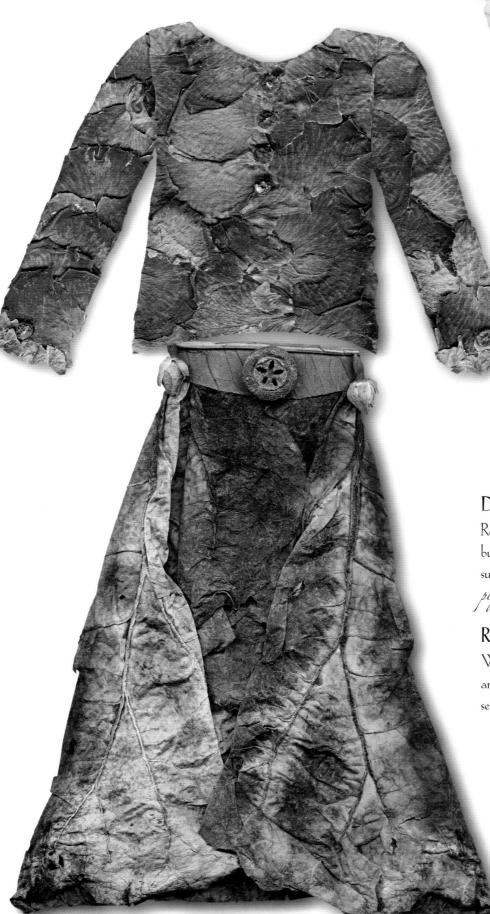

Delphine Shirt

Refined rose petal shirt with seed buttons. Timeless, yet up-to-the-minute; suits a *pique-nique*, or a *soirée*, or a *pique-nique soirée*.

Rhubarb Skirt

Wide-wale rhubarb leaves topped with an oak leaf belt, rosebuds, and a red gum seed. Decorous yet earthy.

We were all in awe of

Fleur's style, understated

and unexpected, though

she always included a

signature red rose petal

somewhere on her clothing.

Fleur Cowl-Necked Shirt

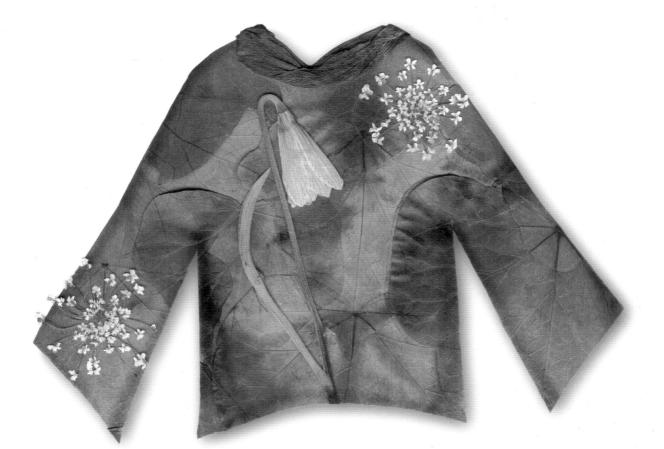

Ivy leaves with overlaid yellow fritillary; asymmetrical sprays of Queen Anne's lace; and, naturally, a red rose-petal cowl collar.

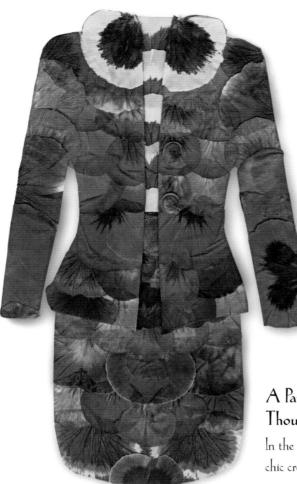

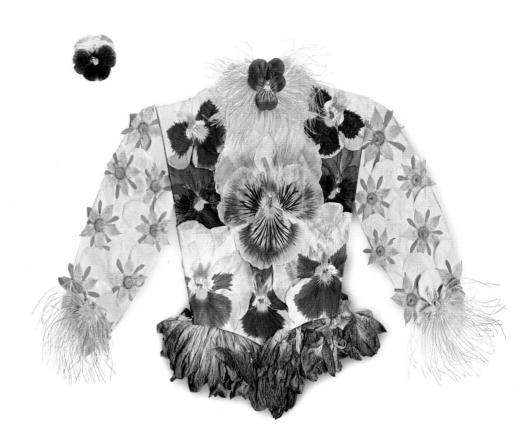

A Pansy for Your Thoughts Suit

In the language of flowers, this chic creation is as well thought out as possible. Just the suit to listen to a suite, *alfresco*.

Arabesque Jacket

When you arrive in this concoction of pansies and buttercups with apache plume trim, expect a flattering fanfare.

Late afternoon concertos on the Green. While the panpipe and piccolo solos are

the perennial favorites, we would be remiss not to mention the attention paid to the audience. How you are dressed at these events is as carefully noted by your fellow concertgoers as the music. Why not choose elegance? This quartet sets the tone.

Rhapsody Dress The Rhapsody is also fashioned of pansies and plumes. Like its counterpoint, the Arabesque, it scores high on entrances.

Pastoral Jacket

The theme is pansies but the variation is oak leaf. Restrained, reflective. Don't miss the rose petal lining.

Quartet

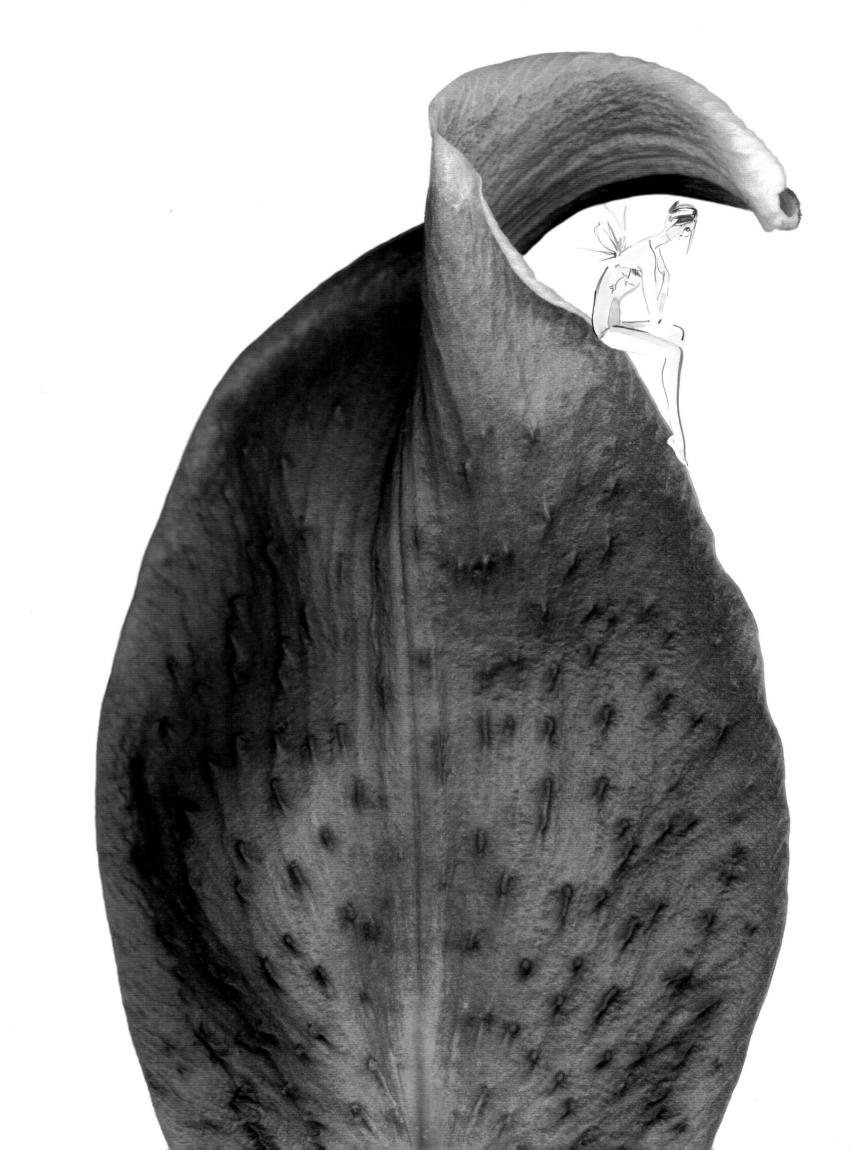

THE FAIRIE RADES DOUBLE DATES SUNSET PICNICS HIDE & SEEK FIREFLY HUNTING MIDNIGHT D NCING MOONBEAM SWIMS MUSICAL EVENINGS NONSTOP PARTIES

FUN & GAMES

Time to start thinking about afternoon outings at the falls, long woodland walks, a gathering of friends at the river. The Season is heating up, and the Ellwand Collection has some of the coolest looks to throw on as you run off to play.

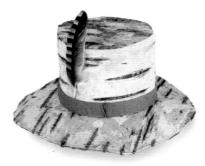

show a little skin

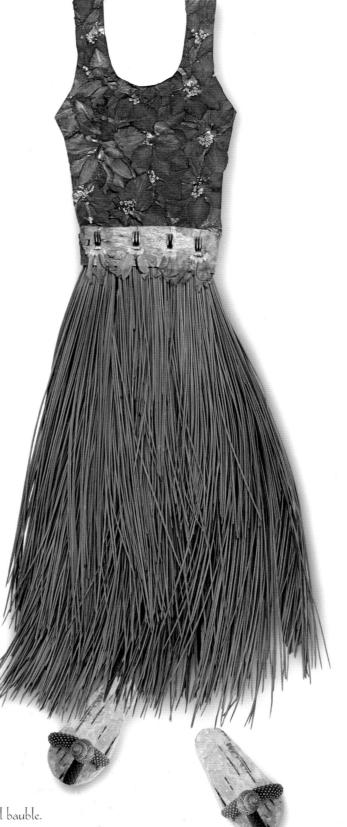

Tippecanoe Hat Birch bark boater with oak band and a stroke of jay feather. Hawaiian Skirt Stone pine needles, silver birch belt with shooting stars. Fill It to the Top Tank A beguiling blue larkspur cooler. Seashell Sandal Hard to say, but easy to wear. Birch sole, anthurium straps, and shell bauble.

The Mata Hari Mysterious pheasant with pink rosebuds and peacock straps.

Bathing Beauties

The Marilyn

peacock straps.

Lip-smacking pink, red, and blue verbena with

The Mae

Lush crow and owl feathers, bottlebrush, and a dash of honesty seeds. Wear these suits whether you intend to swim or not. Create a splash before you touch the water!

The Marlene

Slinky anthurium with Queen Anne's lace, grass twists, and polished pebbles.

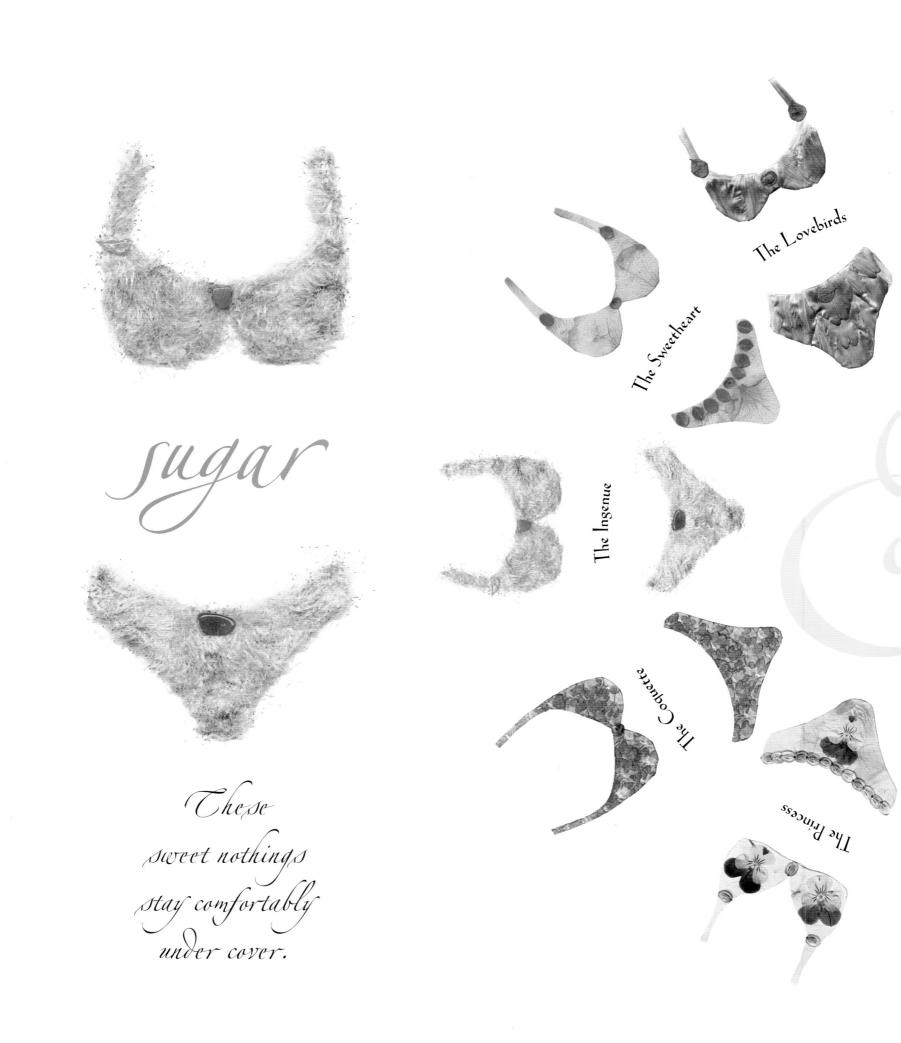

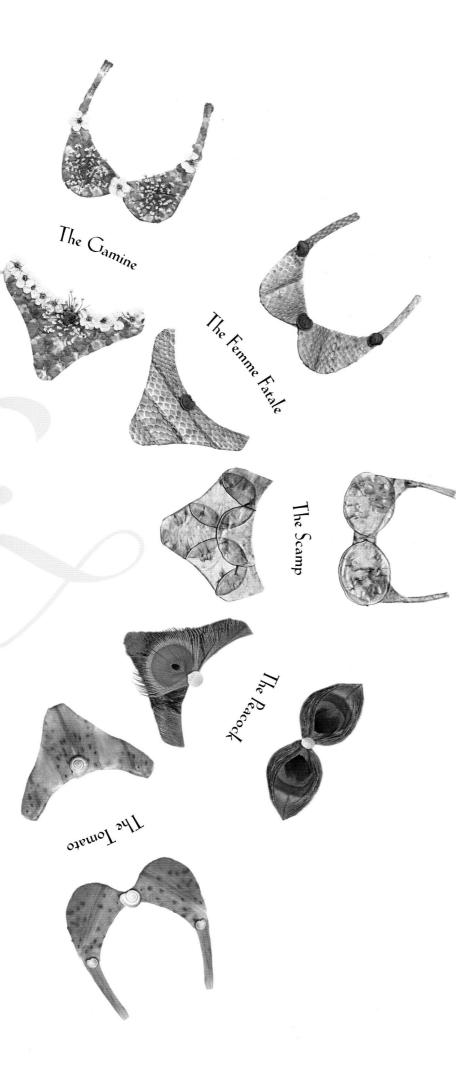

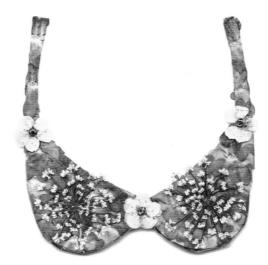

bice

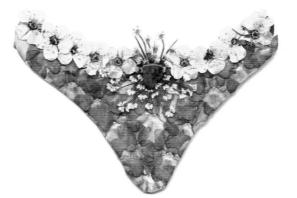

These saucy underpinnings can't wait to take the spotlight.

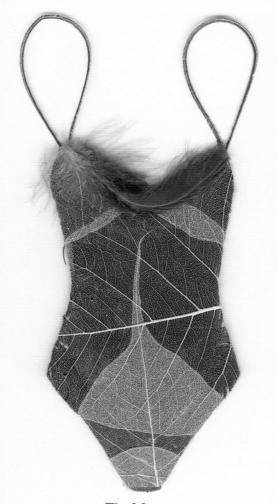

The Huntress Leaf skeleton over crow feathers; pheasant trim and peacock straps.

Well camouflaged, she spends hours in the cattails watching turtles and polliwogs, newts and bullfrogs — an asid huntress with her eyes. 6 6

There's a fairie who strolls every evening

daringly on the same path. He walks in confidence, his jacket's subtle texture blending perfectly with the ancient oaks and rendering him practically invisible. Yet his step is sprightly, for he knows the interior of

> his coat is anything but quiet and hints at his own vibrant inner thoughts.

Oak Leaf Jacket

Oak leaves with aquilegia and dandelion buttons. And of course, the larkspur lining. For the male fairie who laughs at labels. Ample wing slots.

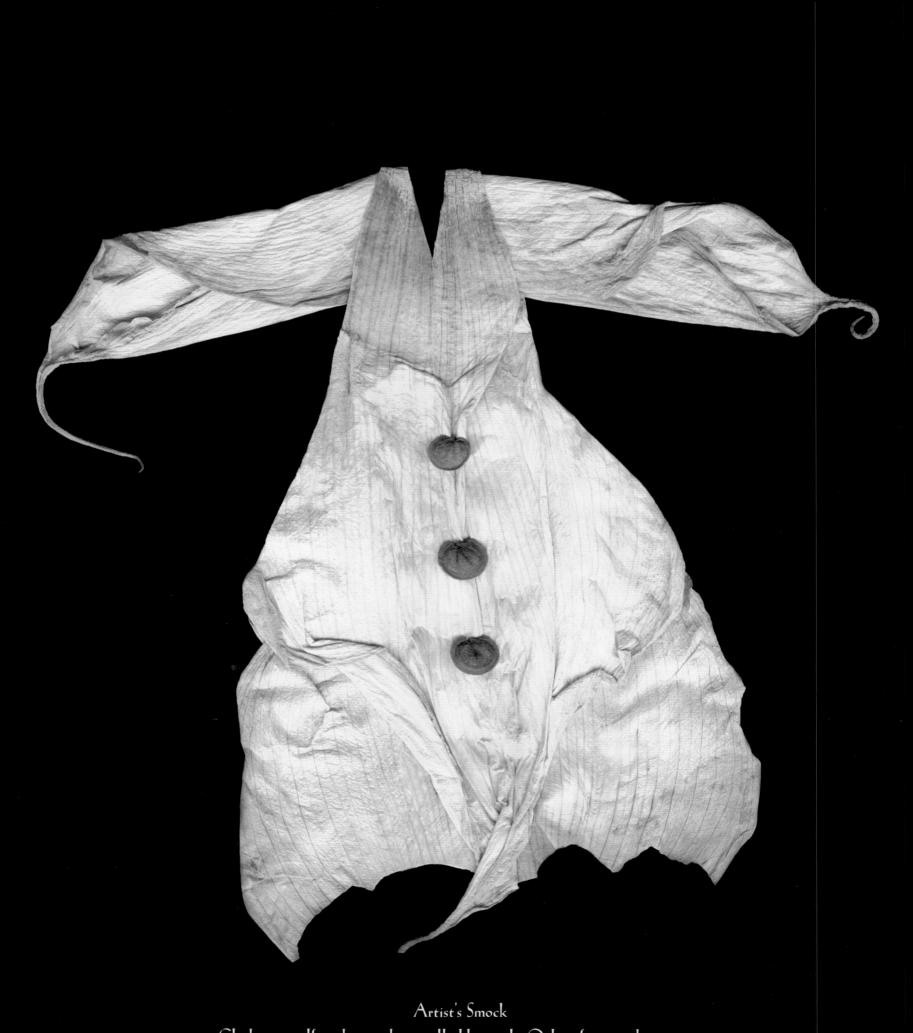

Clothe yourself with panache in calla lily petals. Only a fairie with integrity can carry off this one — naturally, the buttons are made of honesty seeds.

Every acon or so, a fairie comes along who doesn't give a fig for today's sense of fashion. Why should she? She's an artist. Although her creations bear no resemblance to what anyone else is wearing, somehow they convey that Her Choice is the correct one - and that everyone else has

made a Terrible Mistake.

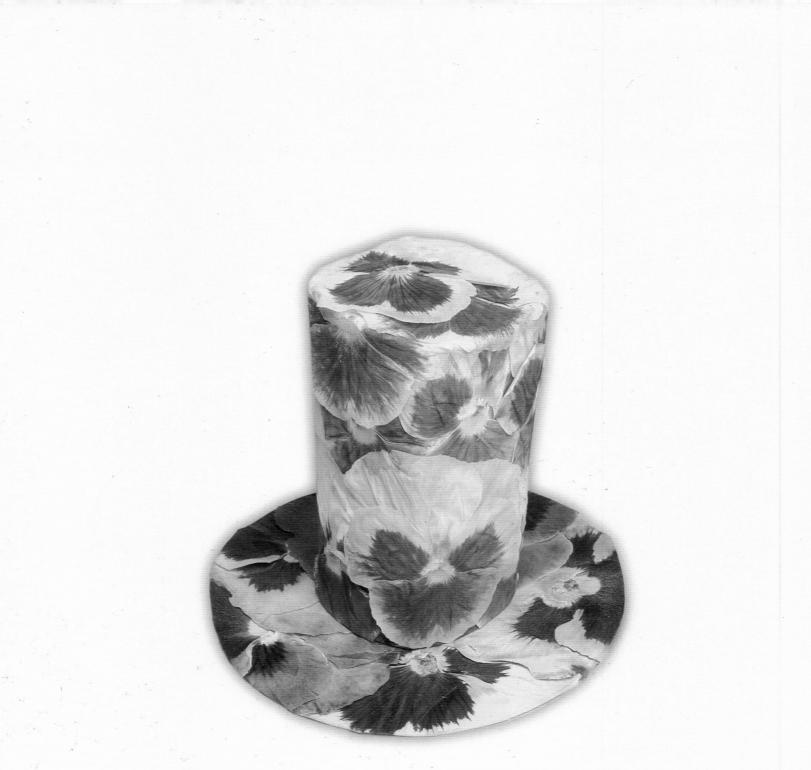

It's Now or Never

Put on your Top-Ten Topper and picture yourself: The stage is bare and you're standing there with adoring fans all around. The King is back!

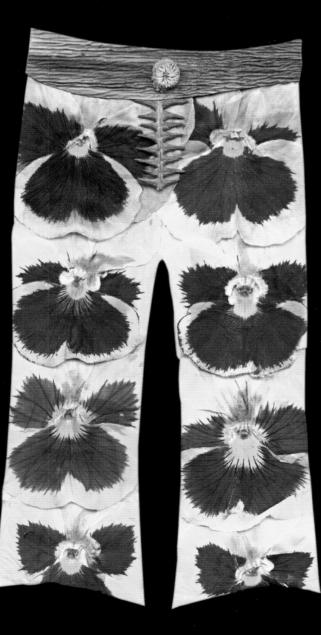

Aloha Jacket

Does your memory stray to the bright summer's day when you first gazed upon the finest of all jackets? Calla lilies with stargazer lining; viola and verbena trim with crystal buttons.

Let's Have a Party Pants

Pansy trousers, belted by a lily leaf, zipped by bracken, and cinched with a daisy center button. They'll move with you, no matter where the music moves you.

These Shoes Weren't Made for Walking But that's OK, because they were made for flying. For when you've kicked off your blue suedes and are heading for the clouds. Pansies with daisy centers.

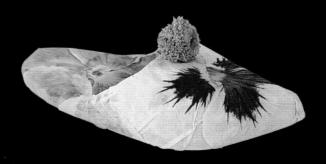

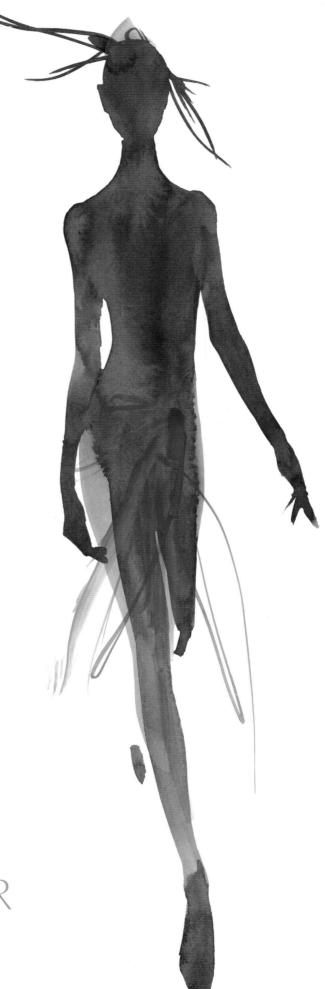

SASHAY HIKE TIPTOE SCAMPER DASH

On tops of dewy grass

Nimbly do we pass,

The young and tender stalk

Ne'er bends when we do walk.

Yet in the morning may be seen

Where we the night before have been.

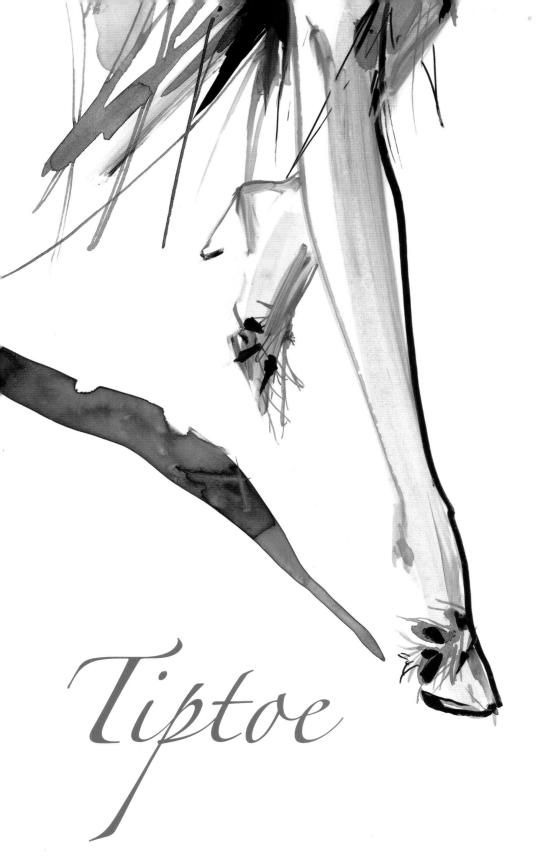

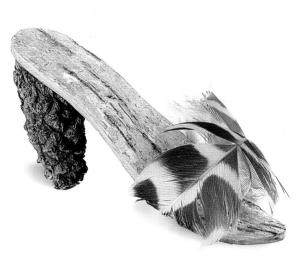

The Hot Heel

A spike sandal that shows some toe. Silver birch soles with pheasant feathers and a pine cone heel.

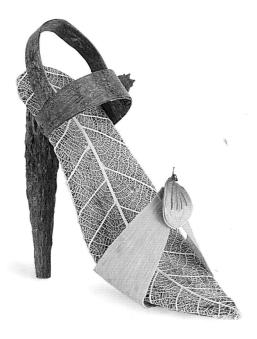

The Balancing Act Stilettos of birch bark covered in skeleton leaf; yellowed grass strap and a sprinkle of cow parsley seed.

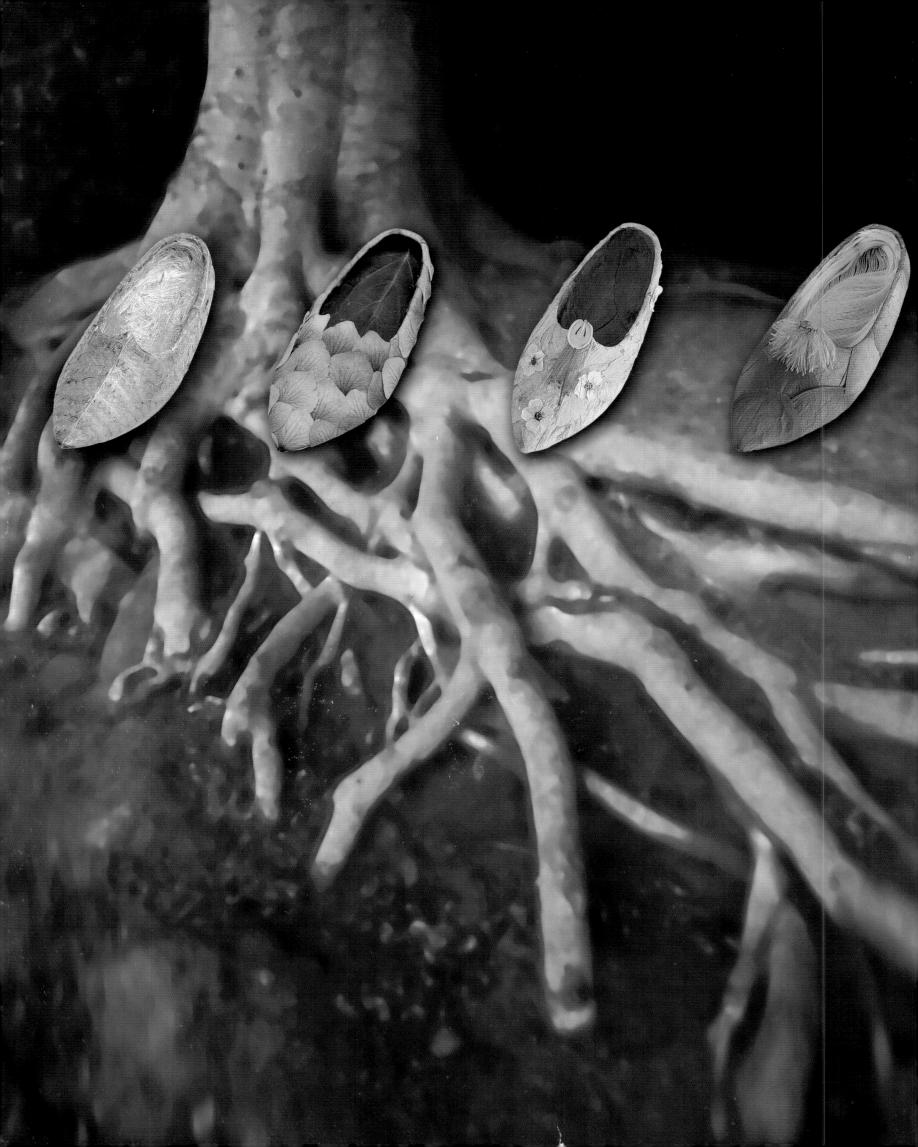

Put Your Best Foot Forward

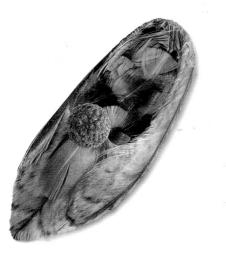

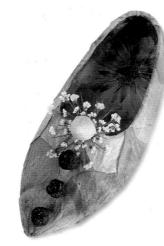

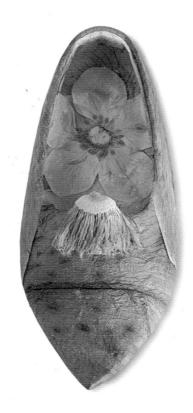

Our flower petal slip-on flats are elegant on earth, easily removable for flight. You'll want to pick a bunch.

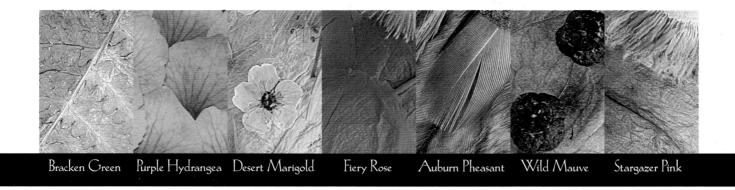

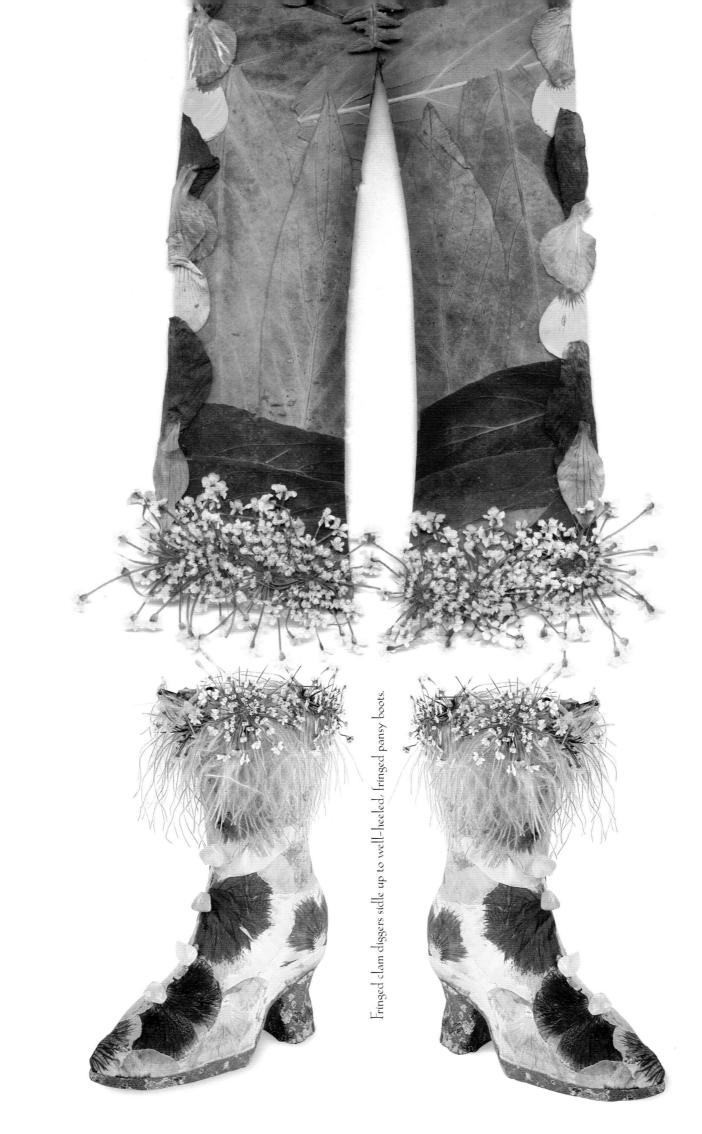

76 }⊛

D

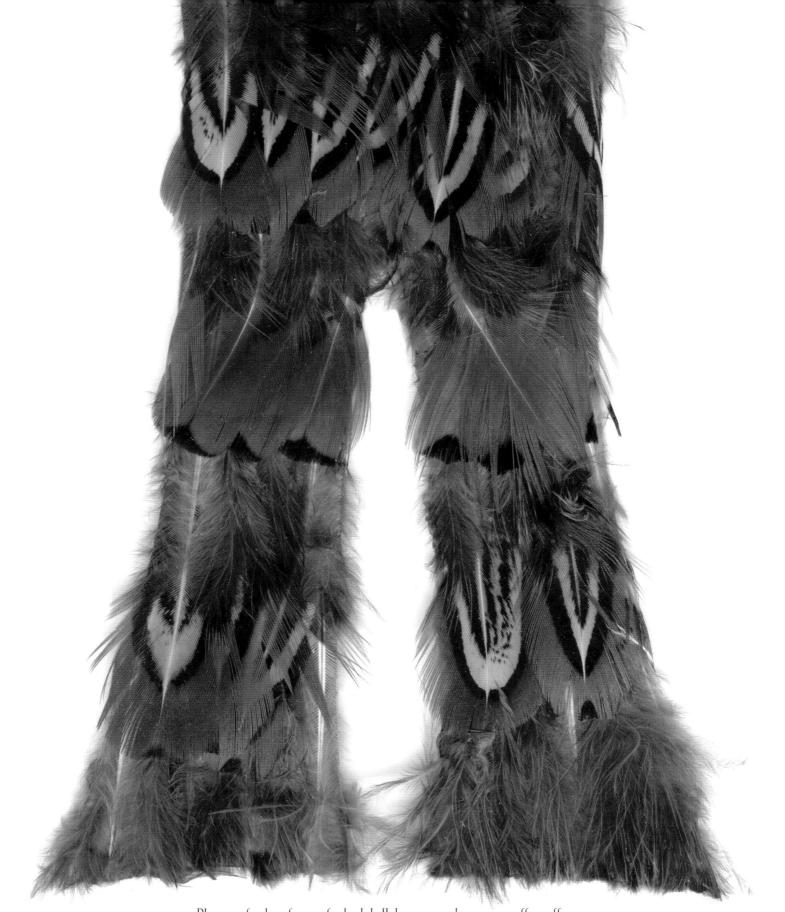

Pheasant feathers feature for both bell-bottoms and not-so-scruffy scuffs.

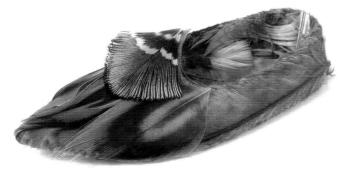

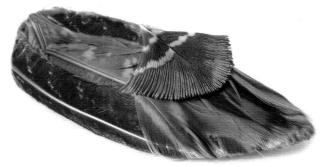

The Varsity

You didn't need a moment's thought about what to throw on for this date—you're a natural. Fifties-style rose petal coat with a sycamore standup collar.

Desert Boots

Heads will turn for a second look at these walk-on-water desert boots. Birch bark covered by leaf skeletons with a strand of peacock feather for a lace.

Flower Child

Rose petal shirt with a collar of beech leaves and one delicious orange cosmos, splashed just there. We guarantee you'll get his attention.

Boss Boots

These are the "must have" boots of The Season. Too bad they're practically one-of-a-kind. Rose petals with hot red verbena and cool apache plume trim.

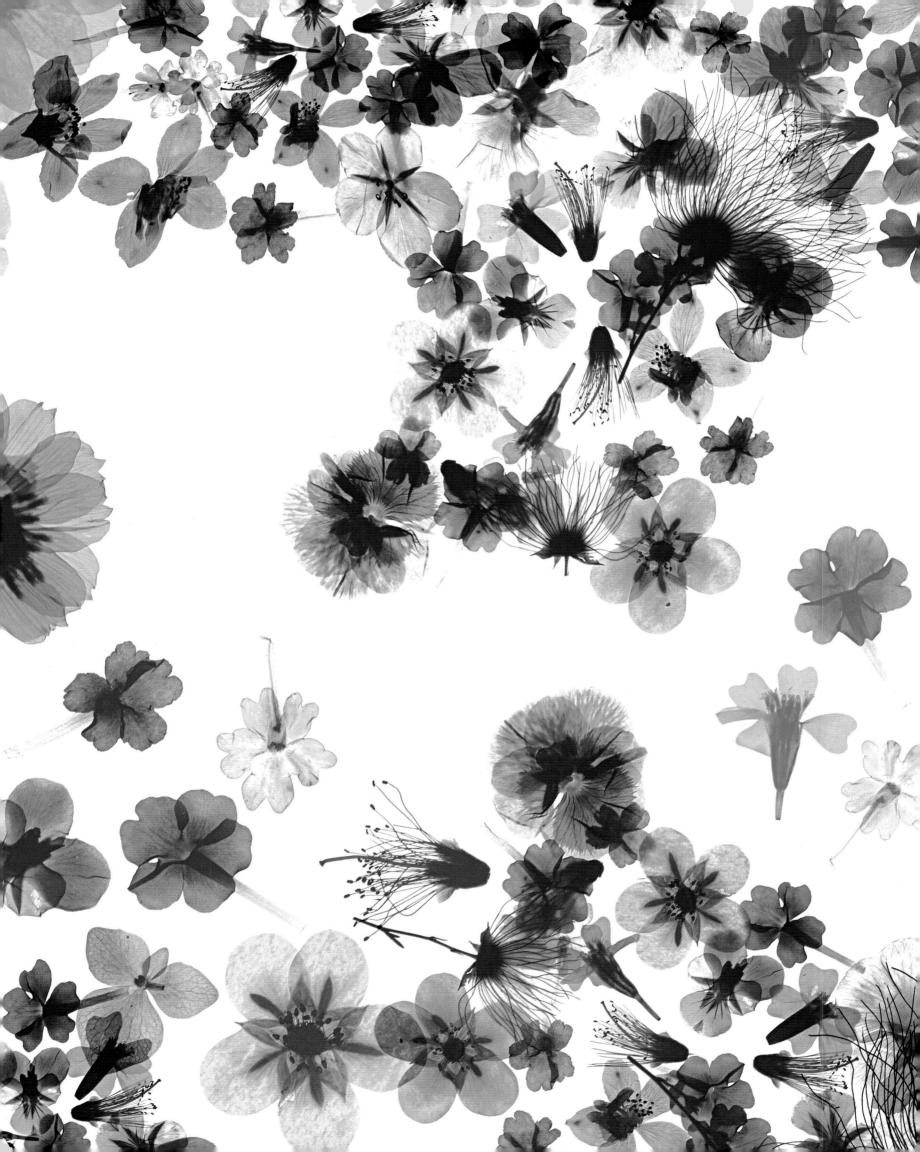

Mix & Match

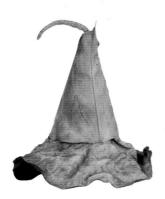

The High & Flighty Hat

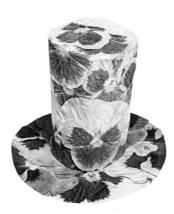

Top-Ten Topper

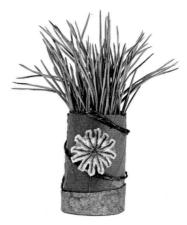

Pine Needle Shako

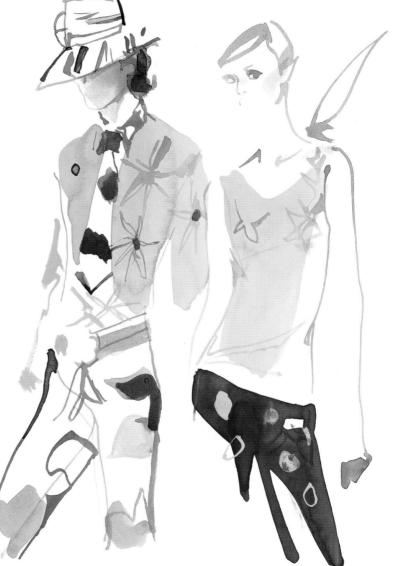

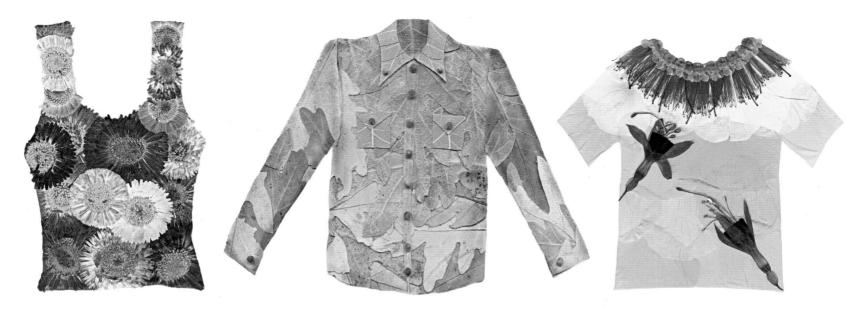

Daisy Tank

Oaken Camouflage Shirt

Cleopatra T-Shirt

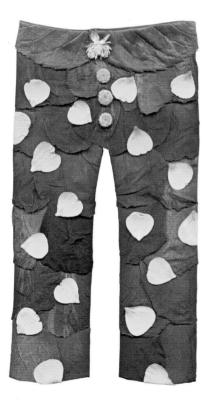

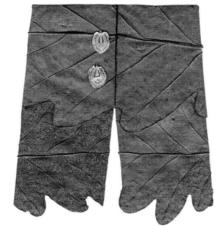

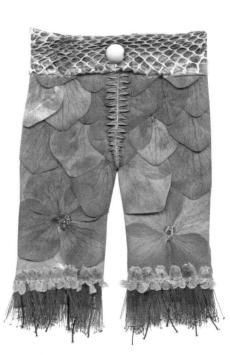

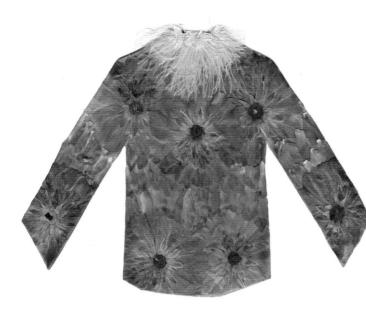

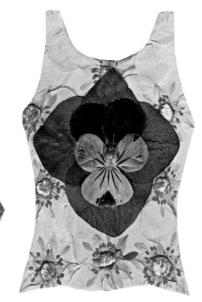

Primary Plumed Shirt

The Blissful Tank

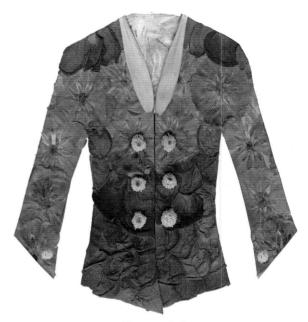

Cosmos Jacket

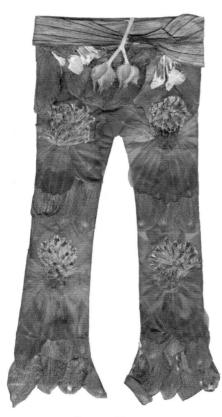

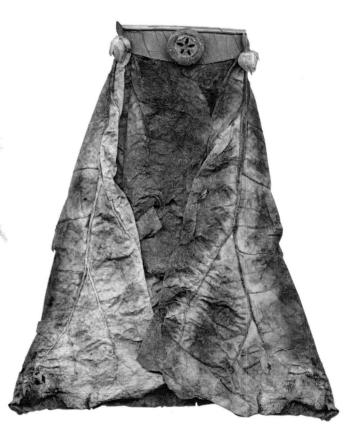

Primary Trousers

Pheasant Trunks

Rhubarb Skirt

Fern Frond Miter

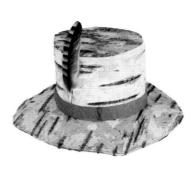

Típpecanoe

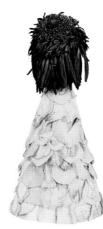

Rose Pierrot

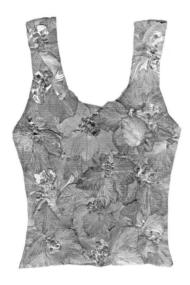

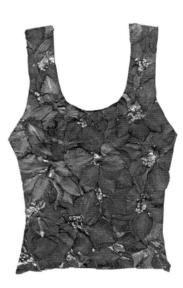

Fill It to the Top Tank

Fast Track Tank

Carnaby Shirt

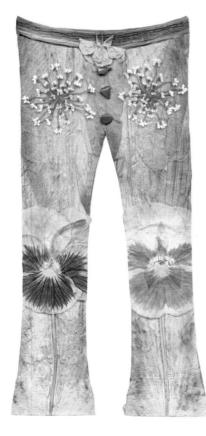

Knee Deep in Pansies Pants

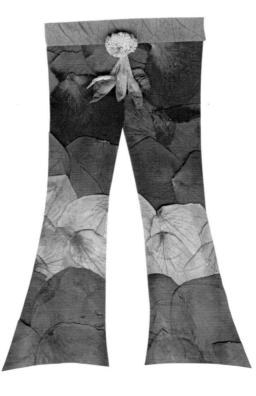

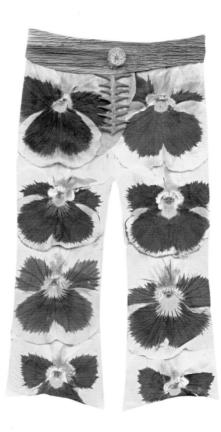

Let's Party Pants

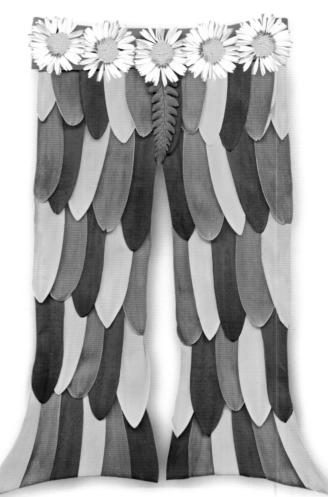

Harlequin Bell-Bottoms Hip hip-huggers of gerbera petals with daisy belt and bracken zip.

"Are you kidding me?" Nope. If you're bold enough to handle it, press the petal to the metal and go from zero to one-eighty by taking flower power away from the ladies. We prefer these hip concoctions without a shirt, but you decide how much of a stir you're prepared to create.

She Loves Me Jeans Lily leaves and daisies; gerbera belt with forget-me-not—and we're sure they won't!

Garden of Eden Trousers Beech leaves with buttercup petals; grass belt trimmed with dandelion.

The Romantic Getaway Weekend

Picture yourself after a starlit

dinner by the sea. You are

dancing barefoot in the

sand. The night air and his

arms are close around you —

no need for a shawl. Suddenly

he whispers in your ear . . . Will you . . .

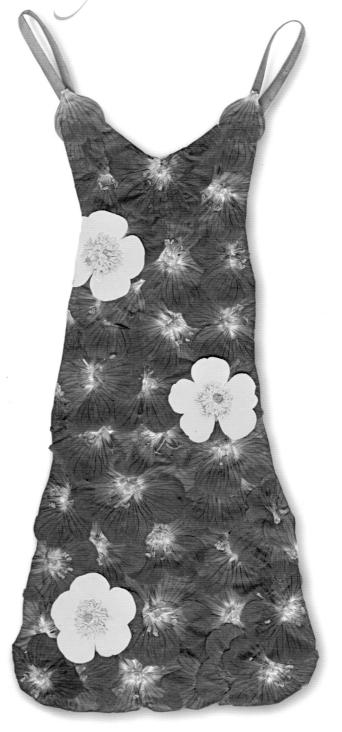

The Bare Minimum

Wild geraniums and buttercups with narrow grass straps. Somehow you knew this would be the weekend that he would pop The Question.

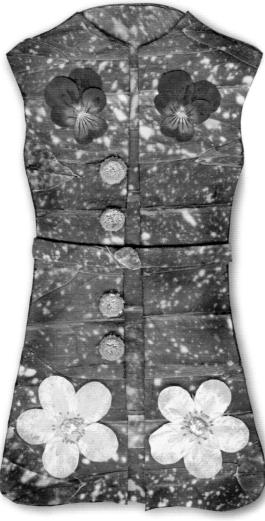

Meet-the-Parents Day Dress Rhododendron leaves with King Henry violas and buttercups, daisy center buttons. Time to share everything with your families and friends.

The Buttercup Beach Suit Toreador pants with matching tank top, all of buttercup. He loves you! Now you'll make your wedding plans.

⊛{ 95

Bonfires flame on hilltops, their embers snapping and sparkling in the velvet sky. Thousands of fireflies gleam like tiny lanterns and spread the glow across the meadow for the bridal party and guests. The flower girls have been gently gathering peacock butterflies to release in a cloud just as Lydia makes her entrance through an archway of calla lilies. Could there be a more romantic time than Midsummer's Sre?

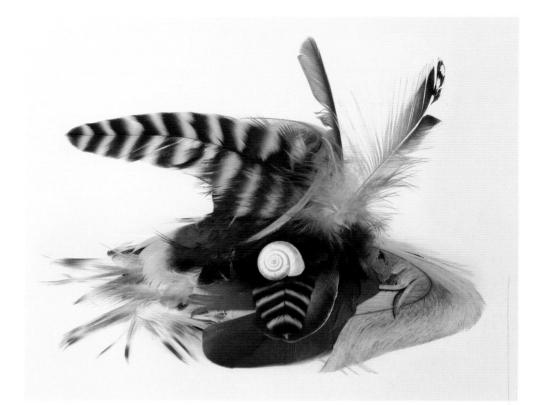

Mother of the Bride

Just yesterday your little girl was flitting over meadows and darting in and out of forest pools. Is it possible that today

you will dress for her wedding?

Mother-of-the-Bride Hat This glorious hat is fashioned of duck, duck, goose. The pat on the head goes to you!

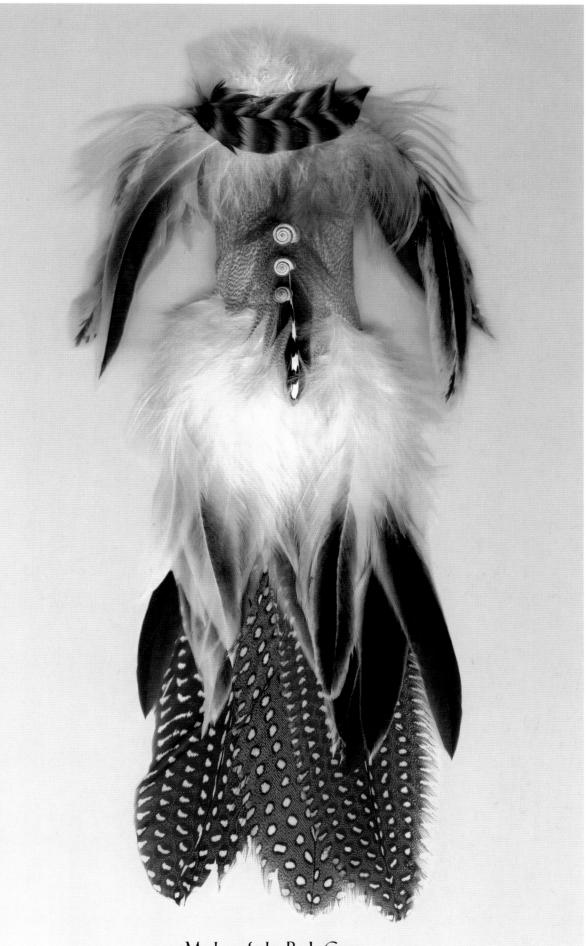

Mother-of-the-Bride Gown This elegant and sophisticated gown of duck and goose feathers with snail shell buttons blends drama and whimsy—a perfect expression of the woman you are.

THE GROOM.

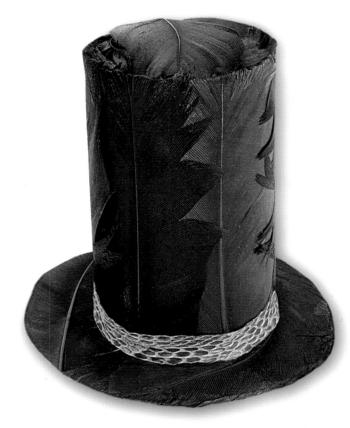

The Cut-Above Crow Top Hat

A splendid tower of gleaming crow feathers bound by snakeskin.

The Cut-Away Crow Jacket

The smoothest of crow feathers with a dash of parrot at the lapel. Snail buttons and epaulettes of pheasant, peacock, and shell for the well-groomed husband-to-be.

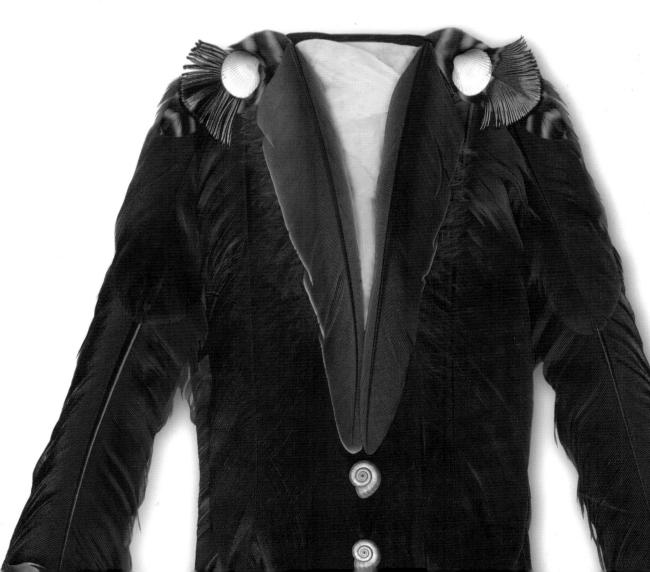

This year's color, celadon green, was spirited straight from a sprite's underwater palace and is freshly interpreted in this flowing gown. The bodice of stargazer lilies is studded with a starlike poppy top, and the demure sleeves are also poppy. Evanescent.

Lily Bridesmaid

Silky crow feathers and a single green parrot feather gather in layers, creating the touch-me velveteen look of the skirt—spellbinding. The bodice and straps are lily leaves; the overbodice, a whispering tracery of skeleton leaf. Sumptuous.

The Maid of Honour

Flower Girl Gown

Flower Girl

Parrot feathers and curls of lily petals with the signature Ellwand loop form the skirt. Skeleton leaves overlay the calla lily bodice, which has puffed, love-in-the-mist sleeves and a burst of bottle brush at the neck. Any flower girl's dream of a dress.

After releasing clouds of butterflies, the flower girls continue spinning their magic, scattering rose petals from their glossy magnolia leaf baskets.

Here comes

I sing of feather gowns

and seils of air;

Of lilies for the

bride most fair.

Bridal wreath caplet with three diaphanous skeleton leaves.

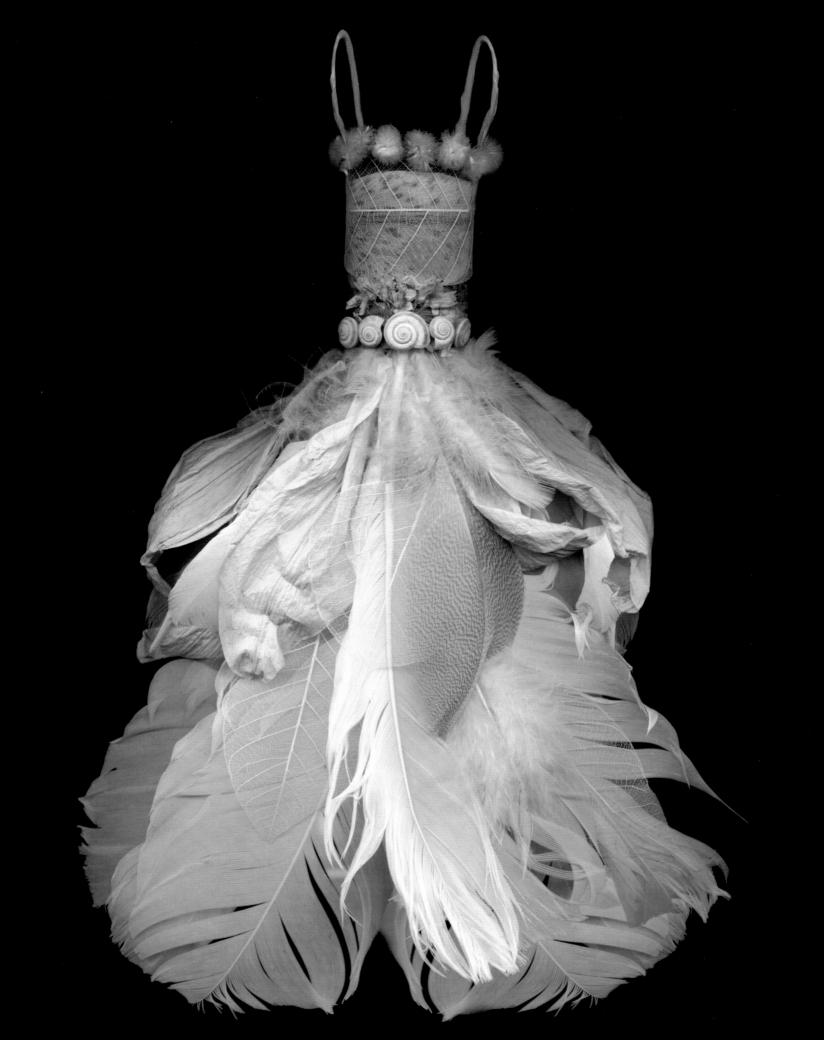

Overlaid lily petal bodice with lily straps and rabbit's foot clover; heather flower and snail shell at the waist; skirt and train of calla lily, goose feather, and skeleton leaf.

Arise, my love, my fair one,

and come away;

for lo, the winter is past,

the rain is over and gone.

The flowers appear on the earth,

and the time of singing has come.

Blossoms

Leaves

Petals

Seeds

Stems

Pods

Buds

Plumes

Shells

Feathers

Bark

To the discerning Ellwand eye, beauty is everywhere.

Seeking the finest and freshest materials, Ellwand conducts extensive gathering trips on two continents and enlists the help of quality suppliers worldwide.

Bark

Feathers

Shells

Plumes

Buds

Pods

Stems

Seeds

Petals

Leaves

Blossoms

Pick-me-up passementerie

acorn top Apache plume seed head ash key seedpod bullrush seed Chinese lantern cow parsley seed cypress cone honesty seed pinecone poppy top red gum seed shed snakeskin

Shells and stones crystal pebble seashell snail shell stone

Plucked from the air crow duck goose jay owl parrot partridge peacock pheasant

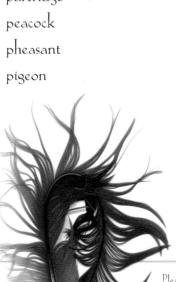

From branch and sine alder leaf American oak leaf bay leaf beech leaf birch bark birch leaf bracken fern cedar bark cotoneaster leaf dock leaf English oak leaf fuchsia leaf ivy leaf lily leaf monkey puzzle leaf purple sage leaf rhododendron leaf rhubarb leaf rose leaf skeleton leaf sweet chestnut leaf sycamore leaf

Found on the ground

variegated sage leaf

grass pine needles thistle thistledown

Coaxed from the earth artichoke crocus bulb

pumpkin

A flower by any name

anagallis

anthurium aquilezia (columbine) bluebell bottlebrush flower bougainvillaea bridal wreath buttercup calla lily cosmos daisy dandelion delphinium desert marigold dianthus forget-me-not freesia fritillary fuchsia gerbera daisy heather blossom hydrangea Johnny-jump-up viola King Henry viola larkspur lavender lilac Mexican bird of paradise pansy pincushion flower Queen Anne's lace rabbit-foot clover flower rosebud and rose petal shooting stars stargazer lily verbena wild geranium

Please note that only regulated game and found feathers are used at the House of Ellwand.

The conturier extends thanks to the designers of this catalogue, art director Chris Paul and associate art director Ann Stott, for their empathy and expertise; copy writer Eugenie Bird for her enchanting lines; fashion illustrator David Downton for capturing the essence of the fairie form; technical assistant Gregg Hammerquist for his wizardry; editorial assistant Monica Perez for her magical powers of observation and organization; and my editor and publisher, Karen Lotz ("Hocus Pocus"), for her vision and support — without which there would be no Ellwand Collection.

1 also would like to thank Alexis Banyon, Christine Corcoran Cox, Cecile Proverbs, Steve Thomas, Brandy Polay, and Lynn Cifford.

This catalogue was printed by Sing Cheong Printing Company, Ltd. in Hong Kong. The text stocks include Nopa matte, Tomohawk, and vellum, printed in four colors with two metallics and a press varnish. The jacket was printed in five colors with foil blocking and a spot UV, plus a matte laminate, on a Nopa gloss art. The endpapers are a woodfree stock. Separations and proofing were done by Bright Arts H.K., Ltd. in Hong Kong and GRB Editrice in Verona, Italy. The text was set in Zapfino, Eva Antiqua, and Cypress. For my mother and father, and for Ruth and Lydia -D.E.

Credits

Page 18: "There sleeps Titania . . . a fairy in." William Shakespeare. A MIDSUMMER NIGHT'S DREAM, 2.1.253-56.

Page 72: "On tops of dewy grass . . . have been." From Thomas Percy, "Sportive Gambols" in REALMS OF MELODY, ed. Geoffrey Callender (London: Macmillan & Co., Ltd., 1916).

Page 110: "Arise, my love . . . has come." Song of Solomon 1:10-12.

Text copyright © 2002 by Eugenie Bird Artwork and photography copyright © 2002 by David Ellwand Illustrations copyright © 2002 by David Downton

All rights reserved. No part of this book may be reproduced, transmitted, or stored in an information retrieval system in any form or by any means, graphic, electronic, or mechanical, including photocopying, taping, and recording, without prior written permission from the publisher.

First edition 2002

Library of Congress Cataloging-in-Publication Data is available. Library of Congress Catalog Card Number 2001058291 ISBN 0-7636-1413-0

10987654321

Printed in Hong Kong

Candlewick Press 2007 Massachusetts Avenue Cambridge, Massachusetts 02140

visit us at www.candlewick.com

Glenview Public Library 1930 Glenview Road Glenview, Illinois

3 1170 00614 9144

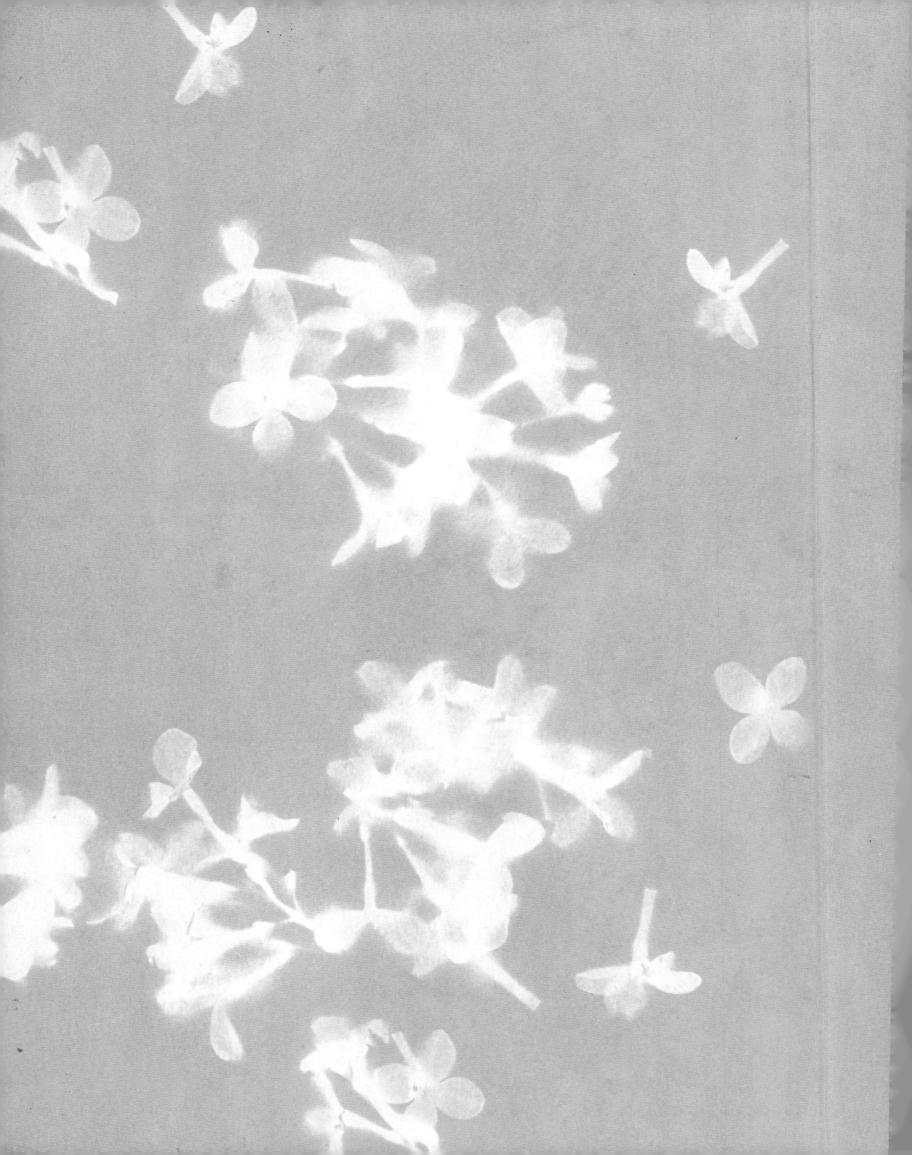